D1577520

Paul CÉZANNE

'IF CÉZANNE IS RIGHT, THEN I AM RIGHT.' MATISSE

Jacket illustration: *The Bay of Marseilles, Seen from L'Estaque*, *c.*1878–1879 (detail), musée d'Orsay, Paris

This edition first published in the UK 1995 by
Cassell
Wellington House
125 Strand
London
WC2R 0BB

Copyright © Somogy Éditions d'Art, Paris, 1995
English translation copyright © Cassell 1995
Works by Maurice Denis, Fernand Léger and
Pablo Picasso copyright © Spadem, Paris, 1995
Work of Georges Braque copyright © Adagp, Paris, 1995

French original published as *Paul Cézanne*

English translation: Ariane Dandoy-Lawson
Consultant: Michael Howard
Designer: Ariane Aubert
Editor: Lydia Darbyshire

All rights reserved. No part of this book may be reproduced or transmitted in any form or by any means, electronic or mechanical, including photocopying, recording or any information storage and retrieval system, without prior permission in writing from the publishers and copyright owner.

Distributed in the United States by
Sterling Publishing Co. Inc.
387 Park Avenue South, New York, NY 10016

Distributed in Australia by
Capricorn Link (Australia) Pty Ltd
2/13 Carrington Road, Castle Hill, NSW 254

British Library Cataloguing in Publication Data
A catalogue record for this book is available from the British Library

ISBN 0–304–34777–9

Typeset by Blackjacks, London
Printed and bound in Italy

Paul CÉZANNE

A life in art

Isabelle Cahn

Foreword by Françoise Cachin

CASSELL

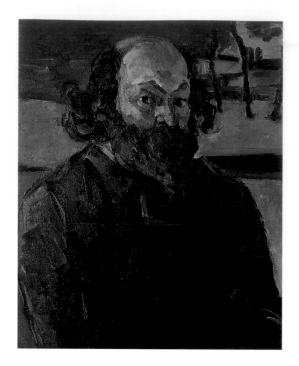

Self-portrait, c.1872
Oil on canvas, 64 x 53cm
musée d'Orsay, Paris

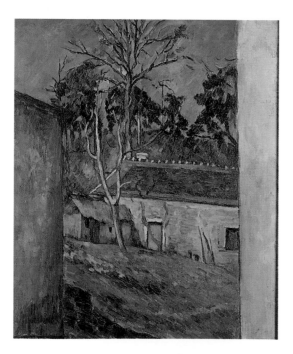

Farmyard at Auvers, c.1879–1880
Oil on canvas, 65 x 54cm
musée d'Orsay, Paris

Contents

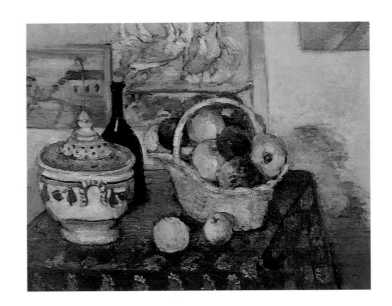

Still Life with Soup Tureen, c.1873–1874
Oil on canvas, 65 x 81cm
musée d'Orsay, Paris

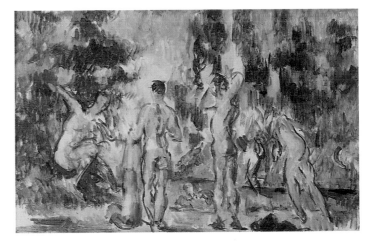

Bathers, c.1890–1900
Oil on canvas, 22 x 33cm
musée d'Orsay, Paris

Foreword

An art book has the great advantage over an exhibition of allowing the author free choice – you can bring together all the pictures you would select for an ideal retrospective. You do not have to worry about those collectors who are so enamoured of their canvases that they will not part with them nor about the statutes governing certain museums and collections that will not permit them to release works for exhibitions in other countries.

The author of this book has also contributed to the Cézanne Exhibition at the Grand Palais, Paris, but within the pages of this book she has been able to bring together an excellent series of essays on those of Cézanne's works that she considers, with justification, to be the essential works, regardless of whether they were included in that exhibition. Fortunately, many of these paintings are in collections in Paris. In addition, we are privileged to have a wide range of Cézanne's work in collections throughout France. Paul Gachet, Isaac de Camondo and Auguste Pellerin had the foresight to acquire works that they generously left to the nation, and many of these are now included in the collections of the musée d'Orsay.

Isabelle Cahn conveys with great skill the complexity and ambiguity of Cézanne the man and the artist, confronting issues that are often reduced to clichés. We may, for example, see Cézanne as the figure depicted by Vollard – a quarrelling Bohemian who produced masterpieces in spite of himself – or we may see the artist recognized by the Modernists as the precursor of twentieth-century art – Fauvism, Cubism and abstraction. Cézanne may have been both these, but he was more. His seclusion was not just the result of his cantankerous disposition; it was also a deliberately chosen way of giving himself the means to complete his work. Above all, he wanted to be a great artist and to find a way of achieving – through his own new and personal 'formula' – art equal to that created by the great masters of the past. He knew he had to be liberated from the academicism he detested and even from the Impressionists who had inspired him. He remained forever indebted to the 'humble and colossal' Pissarro and to Monet, whom he considered to be the greatest artist of his generation. Maurice Denis, in a seminal article on Cézanne written in 1907 (less than a year after the artist's death), wrote: 'He is both the culmination of classical tradition and the result of the breakthrough in freedom of expression and in light that rejuvenated modern art. He is the Poussin of Impressionism.'

<div align="right">

Françoise Cachin
General Director, National Museums of France

</div>

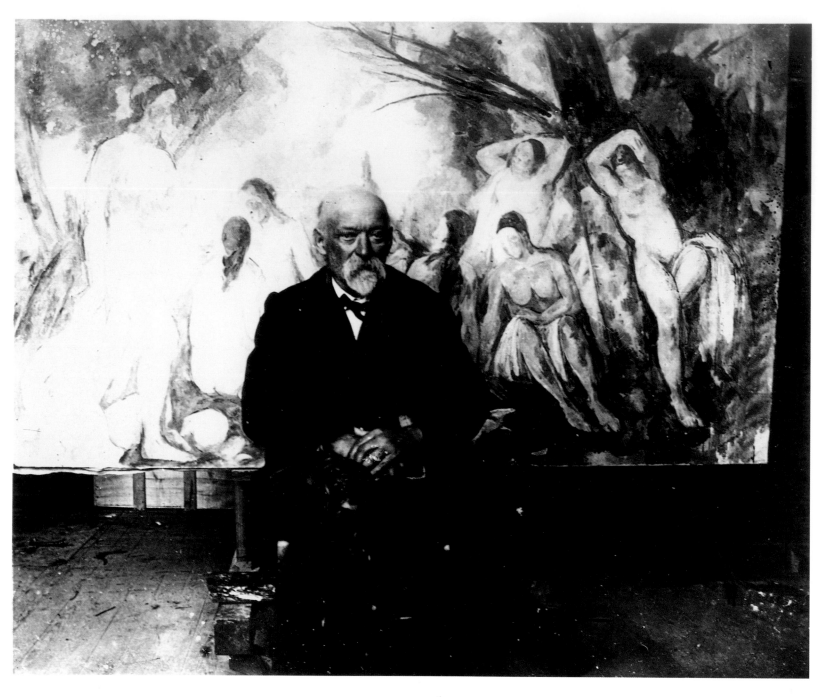

Paul Cézanne in 1904, photographed by Émile Bernard in front of *Bathers*
(now in the Barnes Foundation)

'I paint as I see, as I feel – and I have very intense feelings.'

Cézanne, the Nonconformist

A great deal has been written about Cézanne's personality. At a time when the Romantic idea that eccentricity was a mark of genius still prevailed, he was seen by his contemporaries as a misanthropist, unsuited for work. Like van Gogh and Gauguin, Cézanne became a legend in his lifetime. Writing in 1905 Rivière and Schnerb noted: 'Even an ironist was able to say that Cézanne was a mythical being who did not experience a positive existence.' The artist disturbed and shocked his contemporaries. He was regarded as 'awkward' for rather superficial reasons, which were often far removed from his art – for the eccentricity of his dress, the nonconformity of his behaviour or simply for his whims, for example.

The earliest photographs reveal a rather attractive, southern European with dark hair and large, bright eyes, which give him a gentle but intense look. A studious, romantic adolescent, Cézanne became the somewhat blunt man described by his contemporaries. His behaviour was often provocative – perhaps intentionally so – although this could no doubt be justified by the need he felt to oppose the art establishment of the time and by his taking a leading part in the campaign for a new and revolutionary method of painting. As it was, he carried things

to extremes in a way that resembles the audacity of the inherently timid. However, there was no timidity in his dedication to his art. To all appearances, he did not, even for a moment, doubt his reasons for being different from other painters, preferring rather to question what others expected of him.

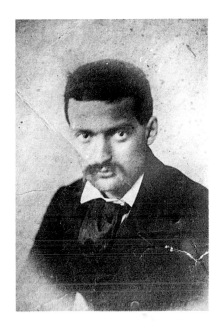

Paul Cézanne, *c.*1861

Isolated by his own singularity, Cézanne certainly appeared as a marginal figure among the sophisticated friends whose company Manet was keeping at the end of the 1870s. In a letter to Zola of 1877, Edmond Duranty noted: 'This might amuse you. Cézanne appeared recently in the little café at the Place Pigalle, wearing one of his old outfits, blue overalls, white canvas jacket covered with paint and a battered old hat.' Photographs taken around Pontoise or Auvers-sur-Oise about 1872 or 1873 confirm this description. They show the artist with long hair and a thick, somewhat unkempt beard and wearing a creased jacket and trousers caked with

*Self-portrait, c.*1866
Oil on canvas, 46 x 40cm
Private collection

mud from the country lanes. Such images reinforce the Romantic notion of the artist going out to confront his subject matter as directly as possible. Even by this time he had the detached attitude of the modern artist, an attitude quite different from that of Manet, who is revealed as a dandy in frock-coat and top hat in Nadar's photographs, or from that of the 'official' painters who chose to be immortalized against the trappings of their luxurious studios.

Though lacking neither education nor wealth (his father was a wealthy banker), Cézanne refused to take part in the social game. His was a solitary existence, not because he lacked affection for his circle of friends but because he dreaded both disappointments and stifling relationships and therefore chose to break away rather than 'get hooked,' as he used to say. Nevertheless, he enjoyed the company of a number of select friends, and in his youth he frequented such artistic circles as the Café Guerbois, the Nouvelle Athènes, the salons of Nina de Villars and Charpentier, the publisher, and also the 'Soirées de Médan' organized by Zola. He remained loyal to his childhood friends – Émile Zola, Paul Alexis and Fortuné Marion – and later, to the exclusion of all others, he became intimate with such painters as Achille Emperaire, Camille Pissarro, Claude Monet, Auguste Renoir, Adolphe Monticelli and, in the last years of his life, with such young artists as Joachim Gasquet, Émile Bernard, Maurice Denis, Ker-Xavier Roussel and Charles Camoin. Their papers and correspondence reveal their impressions of Cézanne's contradictory personality, his outlook on life, his tastes in art and literature and the stages in the development of his career.

All his life Cézanne remained secretive. A relentless worker, he could not bear to be watched while he was at work. Renoir, however, who painted next to him in the south of France, observed: 'It was an unforgettable spectacle... to see Cézanne working at his easel, looking at the countryside around him. He was truly alone in the world, eager, intense, attentive and

respectful. He would come back to it day after day and add one more attempt to the previous one. Sometimes he would leave, feeling quite desperate, and would return home, having abandoned his canvas on a stone or on the grass, prey to the wind, rain and sun, and the painted landscape would be absorbed by the natural surroundings in which it had been left.'

On first sight, Cézanne could be surprising. The young American painter Matilda Lewis noted: 'He looked like [Alphonse] Daudet's description of a man of the south. When I saw him for the first time, he gave me the impression of a pirate, with bulging, big red eyes, which gave him a ferocious appearance. This was emphasized by a short, pointed beard, nearly grey, and such a violent manner of speaking that it would literally make the crockery rattle. I later discovered that I had been deceived by appearances, for, far from being ferocious, he had the gentlest ever temperament, like a child's.' Cézanne was fifty-five when this meeting took place. The last photographs of him, taken by Émile Bernard ten years later, show exactly the same figure of the artist at work: slim and a little fragile, but with a formidable energy radiating from his whole being.

The most important testimonies, both in terms of their number and the quality of their judgement, date from the last years of Cézanne's life, when he lived in seclusion in Aix-en-Provence. Those who visited him during this time are responsible for some popular misconceptions about his personality –

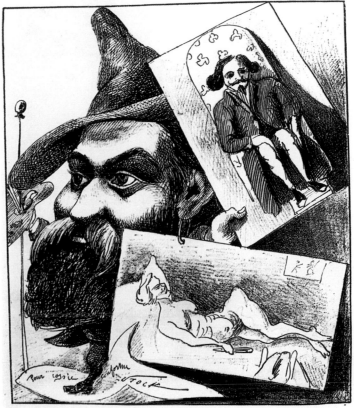

LE SALON PAR STOCK

Incident du 20 mars au Palais de l'Industrie ou un succès d'antichambre avant l'ouverture du Salon

Paul Cézanne with two works rejected by the 1870 Salon. A caricature by Stock.

misconceptions that are too often quoted as fact. They refer to an absent-minded, cantankerous old man, neglectful of his appearance. The first wide-ranging article about the artist was written by the young Émile Bernard and it appeared in *L'Occident* in July 1904. In his 1925 *Souvenirs sur Paul Cézanne*, Bernard reported: 'He was so absent-minded that he would go around with his waistcoat unbuttoned. On Sundays he would attend Mass wearing his best clothes but would often be seen with his collar fastened with a piece of string because he had lost a button on his shirt. He would give his hat a quick brush, but there would be some picturesque dents in it, and his coat would have

some splashes of paint on it.' Louis Vauxcelles, the critic, said that Cézanne, with his short, white beard and leathery complexion, reminded him of 'an old Bonapartist policeman... with unforgettable eyes.'

What is the truth behind this façade of a man who deliberately ignored all the material aspects of life to commit himself exclusively to painting? The poet Léo Larguier, who was doing his military service in Aix in 1902 and who befriended the painter, tried to take all points of view into consideration when he commented: 'Some people find that he looks like a surly old major-general; others saw in him a sort of hallucinated, always angry, foul-mouthed vagabond with a purple nose. None of these images is correct. Those showing a boorish, dirty Cézanne are poor caricatures, done by artists who know nothing about provincial life. ... In winter he would, indeed, put on a jersey that showed beneath his jacket, but it would hardly be out of place on the Cours Mirabeau or in the Square Saint-Jean-de-Malte, and it definitely was the right outfit to go out to paint at Les Pinchinats or Le Tholonet.'

Cézanne ignored all criticism, hostility and even hatred, including that of his father, the Salon juries, journalists, who were quick to criticize, and some of the citizens of Aix. He never allowed anyone to distract him from his chosen path or to influence his life-style. Although late in life he enjoyed significant success and was much admired, he changed no aspect of his behaviour or habits. His last studio, in the chemin des Lauves on the outskirts of Aix, remained noticeably unostentatious. When fame caught up with him he entrusted others – in particular his son, Paul, and his dealer, Ambroise Vollard – with the care of his paintings. Cézanne explained this to Léo Larguier: 'You see, ambition and glory count for nothing to the artist, who does his work because it is God's will, just as the almond tree produces flowers... and the snail its slime.'

Cézanne's Doubt

Although he always concentrated absolutely on his work, Cézanne often doubted his own ability to achieve his ultimate purpose. In 1906, the year of his death, he wrote in a letter to Émile Bernard: 'Will I ever attain the aim that I have for so long sought and pursued? I hope so, but until I do, I will have that vague feeling of disquiet. It will disappear only when I arrive at a satisfactory solution, which means that I will have achieved something that has not been achieved in the past and so will be concrete proof of my theories. Theories are always easy. It is only when you try to demonstrate them practically that you

come up against obstacles. This is why I carry on with my quest.'

We know from Cézanne's *Mes Confidences* that the literary figure with whom he most closely identified was the artist Frenhofer, the hero of Balzac's short story *Chef-d'oeuvre inconnu.* Like the fictional Frenhofer, Cézanne's relationship with his art was fraught with anxiety. When, in Vauxcelles's words, he was 'desperate with his titanic struggle,' sudden outbursts of rage would make him destroy or abandon a canvas. He worked slowly, building up a painting stroke by stroke and deliberating at length about the position of each brush mark. Maurice Merleau-Ponty (basing his remarks on Émile Bernard) related that Cézanne required 'a hundred working sessions for a still life, and a hundred and fifty sittings for a portrait. What we call his "work" was nothing more than the manifestation of his quest and effort.' The paintings of his youth seem especially charged with the doubt to which Merleau-Ponty referred, but the mature works too are affected by it. This doubt may be why Cézanne's correspondence continually refers to his works as 'studies' or 'sketches.' His energy and his concentration were focused on the realization of his ultimate ideal, and each of his paintings was merely a step to that end.

Watching him painting his portrait, Vollard remarked on the difficulty that Cézanne was experiencing in completing the work. 'In my portrait there were, on my hand, two little blank areas of canvas. I commented on them, and Cézanne replied: "Later today I will work at the Louvre, and if all goes well perhaps tomorrow I will find exactly the right shade to fill in those blanks. You must understand, M. Vollard, that if I were simply to apply some paint there, I would have to work over the whole of my painting again, beginning with that area."' The concentration that he brought to bear on the tiniest detail can be explained only in terms of his determination to achieve an entirely personal form of expression. He disregarded both the naturalism and symbolism praised by his contemporaries because, in his eyes, painting could be regarded neither as a 'natural' perception of the world nor as the reduction of images to predetermined intellectual forms. For most of his life, Cézanne worked to develop an original artistic language in which he could formulate his perceptions through the medium of painting. His guides in his quest were the old masters whose works he most admired in the Louvre – Titian, Veronese, Rubens, Poussin and Delacroix. Apart from them, he depended on his *sensations* (feelings), a key word in his vocabulary, although these feelings were a source of doubt and led to endless questioning. In June 1899 he touched on this in a letter to Henri Gasquet: 'I continue to

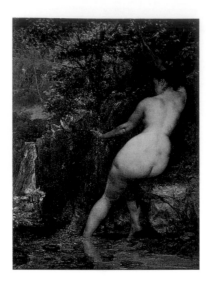

Gustave Courbet,
The Source, 1868
Oil on canvas, 128 x 97cm
musée d'Orsay, Paris

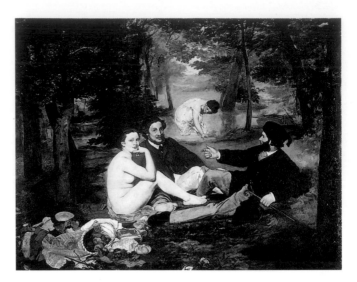

Édouard Manet,
Le Déjeuner sur l'herbe, 1863
Oil on canvas, 108 x 264cm
musée d'Orsay, Paris

search for a way to express these confused feelings, which we bring with us into the world when we are born.'

Driven by his quest, Cézanne worked tirelessly on a limited range of subjects: Mont Sainte-Victoire, L'Estaque, dark forests and still lifes. In his still lifes he painted time and again the same fruit dish, the same Marseilles pottery, the same ginger jar and the same drapes of fabric, which he kept in his studio. His compositions reveal a preference for pyramidal arrangements, which convey a simplified, 'primitive' vision of the world – whether in the outline of Mont Sainte-Victoire, in the grouping of items in a still life or in the disposition of bathers in a landscape.

Towards the end of his life he gave in to Émile Bernard's request that he should put into words his theories about painting, but he was irritated by Bernard's analytical and abstract mind, which he often found too detached from the emotions and visual impressions that he considered to be the only true sources of inspiration.

Cézanne's views were not based on any established certainties or received theories. Throughout his attempts to achieve absolute control over the development of his work, he never stopped searching for the best way of transferring his feelings to canvas. He had no aesthetic preconceptions, as he noted in a letter to Bernard of October 1905. 'Whatever our temperament or our feelings when we confront nature, we must find a way to render what is in front of us, no matter what has happened before.'

Cézanne's search for truth in painting demanded complete commitment and a life devoted to study and work.

A 'Couillarde' Manner

Cézanne's early works reveal something of his passionate, dreamy nature, but from his youth he made a determined effort to control his temperament. His childhood friend, Émile Zola, had lived in Paris for two years when Cézanne

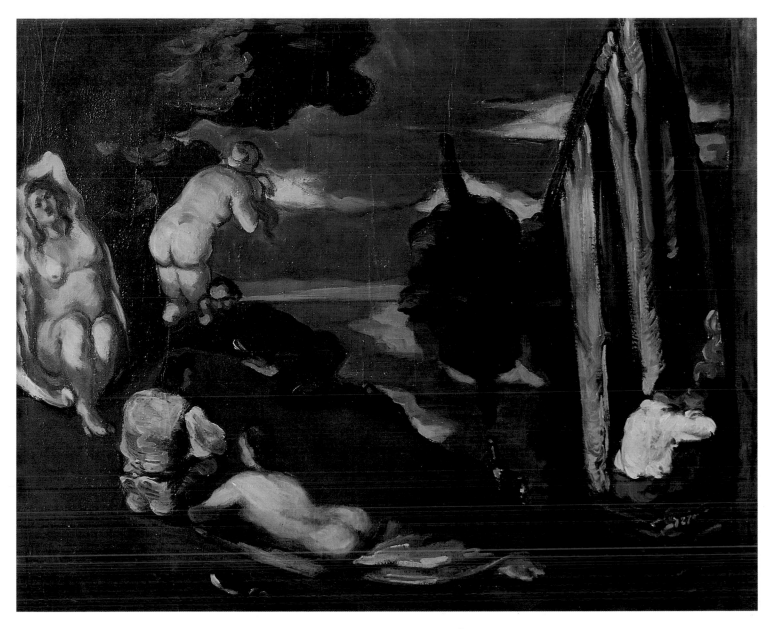

Pastoral Scene or *Idyll, c.*1870
Oil on canvas, 65 x 81cm
musée d'Orsay, Paris

arrived there to study, and Zola set him a strict timetable for his work. 'From six in the morning until eleven you will go to a studio to paint from life. You will then have lunch, then, between noon and four in the afternoon you will copy a masterpiece of your choice in the Louvre or the Luxembourg.' This rigorous programme suited the energetic and determined twenty-two-year old, who was nurturing the twin ambitions of entering the École des Beaux-Arts and of exhibiting at the Salon. Cézanne achieved neither ambition: he was rejected by all the official art establishments, and exhibited in the 1882 Salon only through the intervention of his friend, the painter Antoine Guillemet. In 1870, in an article in *L'Album Stock*, he explained this antagonism to a journalist. 'I paint as I see, as I feel – and I have very intense feelings. They [the Salon artists] feel as I do and they see as I do, but they are timid and produce Salon art.' His attempts, year after year, to submit his works to the Salon's selection committee became

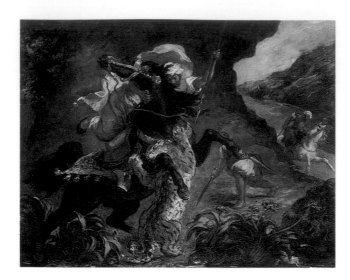

Eugène Delacroix,
The Tiger Hunt, 1854
Oil on canvas, 73 x 92cm
musée d'Orsay, Paris

Honoré Daumier,
The Robbers and the Ass, 1858
Oil on canvas, 58 x 56cm
musée d'Orsay, Paris

something of a standing joke. An article in *Le Rappel* in 1874 noted: 'No Salon jury would ever even dream of accepting a single work by this painter, who brings his canvases in on his back like Jesus carrying his cross.' The barriers between Cézanne and the art establishment that arose in these tumultuous times were never completely dismantled in his lifetime.

Before he discovered the revolutionary works of Courbet and Manet, the young painter from Aix submitted to a strict apprenticeship. It was an especially difficult period for him, partly because, for the first few months that he was in Paris, he was lonely and unknown and partly because he had chosen a sombre palette – paints for 'death and mourning,' as Lawrence Gowing called it. His studies from life made his fellow students at the Atelier Suisse laugh, and they kept him out of their societies.

In 1863, accompanied by Zola, he visited the Salon des Refusés and saw the works of the avant-garde artists whose works were not admitted to the Salon. He was particularly struck

by a large canvas by Manet (now known as *Le Déjeuner sur l'herbe*) showing people in contemporary dress having a picnic on the grass, a work that parodied contemporary art practices. Manet's reworking of traditional themes inspired Cézanne to attempt several compositions with figures in landscapes, including his own version of 'luncheon on the grass,' pastoral scenes, the temptation of St Anthony and bathers. Manet was his first master, but Cézanne also admired Daumier, Delacroix and Courbet.

Although Cézanne was wary of being influenced by other painters, which he felt could paralyse artists, perhaps for an entire generation, he could not wholly escape Courbet's influence in the 1860s and 1870s. Matisse commented on this: 'Cézanne did not have to fear Poussin's influence because he was certain not to take on Poussin's forms, but when Courbet got through to him, as he did to most painters at that time, Cézanne's technique reflected Courbet's too strongly, and Cézanne's expression was limited by it.'

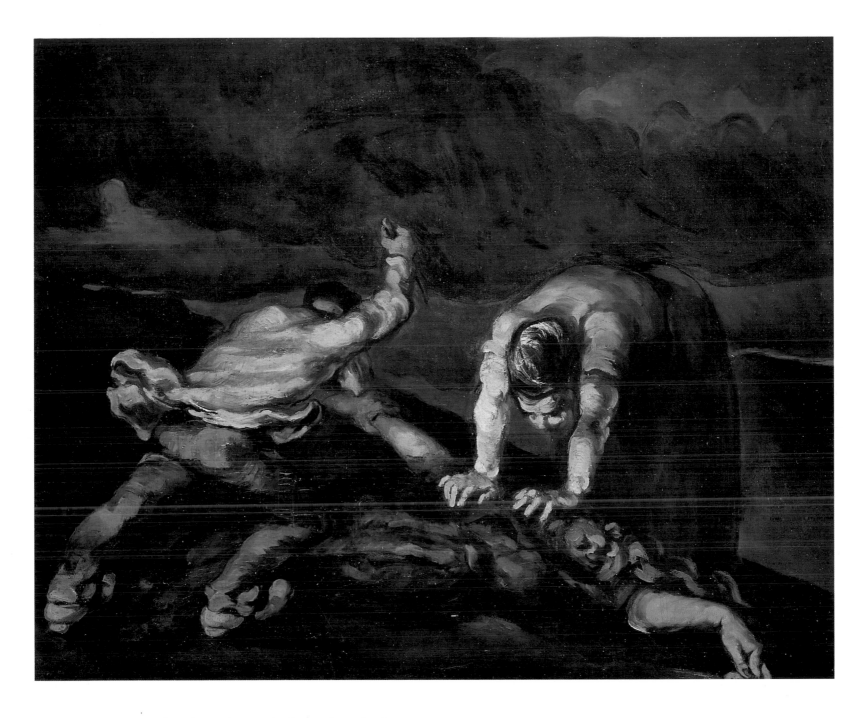

The Murder, 1867–1870
Oil on canvas, 64 x 81cm
Walker Art Gallery, Liverpool

Cézanne also loved tenebrism, the dark, brooding quality found in the works of painters such as Francisco de Zurbarán and José de Ribera. His first works were sombre and represented violent events such as murders, rapes, abductions and orgies, which contrasted strongly with the pastoral scenes inspired by his romantic vision of the world. These gloomy works were an outlet for his dreams and fantasies, an illustration of a world of unsatisfied passions that fcd on literature. Cézanne knew Baudelaire's poem 'Une charogne' ('Carrion') by heart, and he enjoyed depicting the sudden brutality that could arise between the delights of love and the

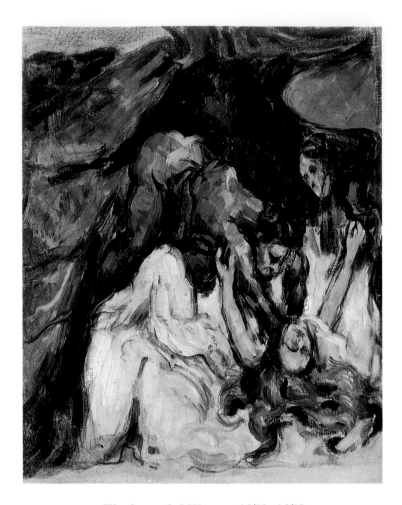

The Strangled Woman, 1870–1872
Oil on canvas, 31 x 25cm
musée d'Orsay, Paris (gift of Max and Rosy Kaganovitch)

technique, and, after the 1870s, he gradually gave up the thick, vigorously applied impasto, which he, rather humorously, called 'couillarde' ('ballsy'). Little by little he moved away from painting the subjects that particularly appealed to him – images of orgies, murders and rapes – and began to work on depicting, in an as yet ill-defined way, something beyond the mere illustration of well-worn subjects.

The Impressionist Experience

From the end of 1872 and throughout 1873 Cézanne lived, not in Paris or the south of France, but in Pontoise and Auvers-sur-Oise. This retreat enabled him to begin working in a new direction. Abandoning his tenebrist style and imagined subjects, he concentrated on reality as it appeared around him. He later described the change to Émile Bernard: 'Imagination is all very well, but you have to be tough. My contact with the Impressionists showed me that I had to become a student of the world, that I had to go back to my studies.'

He often joined Pissarro to paint in the countryside. The two painters had known each other since 1861, and Pissarro was the first artist to recognize the nature of Cézanne's talent, owning no fewer than fourteen of his works. The paintings they worked on at this time show

horrors of death. Working in thick paint and using his palette knife to define shapes, he moulded his subjects with the flat of the blade and applied slabs of colour to indicate light. This rich, supple language was drawn from Courbet's art, but it portends the main elements of his mature style: shapes, moulded by colour, dark outlines and the breaking down of traditional perspective. The works of Cézanne's youth, even though they are sometimes thought of as romantic, are characterized by the vigorous use of light. A great admirer of Delacroix, Cézanne used chiaroscuro to convey the drama of his subject matter, but he quickly abandoned this

identical subjects – views of villages with red roofs, green fields, ploughed red fields and the grey skies of the Ile-de-France – but they also show the influence of each on the other. Cézanne painted a copy of Pissarro's *Landscape in Louveciennes*. His palette lightened as he abandoned the stark contrasts of his earlier works and his technique became more subtle, even though many of his paintings still showed considerable impasto. For his part, Pissarro began to show a much firmer structure in his works.

At this time Cézanne began to paint with distinct brush strokes, juxtaposing them to build up a subject without first enclosing it with a preliminary line drawing. For larger areas he swept over his canvas with a hatching of long, slanting strokes. He had no interest in the objectivity of the Impressionists but gave to each object an equal importance as he built up an entirely personal system of portraying what he saw. Writing in July 1904, Émile Bernard recalled Cézanne as having said: 'There are two aspects of a painter – the eyes and the brain – and they must help each other. A painter must work to develop them together, the eye by learning how to look and the brain by organizing sensations in a logical way so that they can be expressed.' This statement of his beliefs, formulated several years later, seemed to spring from the fusing of nature – the objective source of inspiration in painting –

Camille Pissarro, *Portrait of Cézanne*, *c.*1874
Oil on canvas, 73 x 59cm. Private collection

and the practical working of artistic technique, with which Cézanne experimented during this period when he worked with Pissarro.

His main links with Impressionism arose through his friendship with Pissarro, Monet and Renoir and his admiration for Manet. He shared with them a desire to exhibit his works – his heavy impasto landscapes, his parodies, his erotic scenes and his figures, with their simplified outlines – all of which had been rejected by the selection committee of the Salon. The Impressionists allowed Cézanne, who had longed to exhibit in the Salon, to include his works in

Pissarro Setting off to Paint,
1874–1877
Pencil, 19 x 11cm
musée du Louvre, Paris
(Département des Arts
Graphiques, Fonds Orsay)

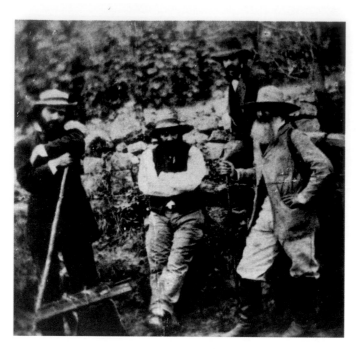

Cézanne (*centre*), Pissarro (*right*)
and two friends

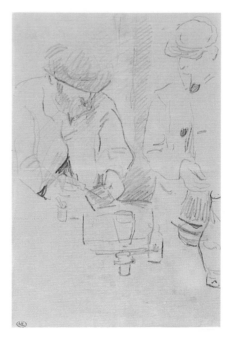

*Dr Gachet Watching Cézanne
Making an Etching, c.*1873
Charcoal, 20 x 13cm
musée du Louvre, Paris
(Département des Arts
Graphiques, Fonds Orsay)

two of their exhibitions, those in 1874 and 1877. Nevertheless his paintings clearly illustrate the differences between his style and that of the Impressionists, which allowed figures to merge into the atmosphere. Cézanne remained fundamentally attached to the subject and the form of his paintings. He never wholly succumbed to the naturalistic vision propounded by his friends, wanting instead, as Maurice Denis later commented, to make Impressionism into something as solid and durable as the great masters he saw in the museums.

The critic Jules Castagnary believed that Cézanne was pursuing his beliefs to the limit and was in danger of sinking into a kind of dead-end romanticism, 'in which nature was nothing but a pretext for dreams and in which imagination was nothing but private, subjective fantasies that have nothing to do with basic intelligence because they can be neither controlled nor verified.' Cézanne's work met with deep hostility, and even his friend Zola expressed some reservations in *Le Sémaphore de Marseille* in April 1877: 'M. Paul Cézanne... is without doubt the greatest colourist of the group. ... When [he] learns to control himself he will produce work of the finest quality.'

Amid all this animosity Cézanne drew considerable support from Victor Chocquet, a collector of modern art, whose passion for Delacroix's work – a passion shared by Cézanne – cemented their friendship. At Chocquet's

Camille Pissarro,
Hillside at L'Hermitage, Pontoise, 1873
Oil on canvas, 61 x 73cm
musée d'Orsay, Paris

request, Cézanne worked on seascapes and views of the Bay of Marseilles while he was staying at L'Estaque. It was there, in the brilliant summer light, which makes shapes indistinct and blurs outlines, that Cézanne abandoned his technique of building up the subject with small brush strokes. The changing skies of the Ile-de-France had lent themselves perfectly to this practice, but the clear air of L'Estaque revealed a different vision. He described his feelings in a letter to Pissarro in 1876: 'The sun is so intense that all objects seem to detach themselves from their background and appear not just as black and white silhouettes but as blue, red, brown and purple ones. I may be wrong, but [the light] seems to me to suppress all roundness and to make everything two-dimensional. Our beloved landscape painters from Auvers would be so happy here.'

I was determined to work in silence

This impression of flatness drove Cézanne to work in an entirely new way. In 1877, the last time one of his paintings had been included in an Impressionist exhibition, his work failed, and he withdrew from the group to develop his own working practices, which he elaborated in the following years. Disregarding the tonal division beloved of the Impressionists, he shaped motifs

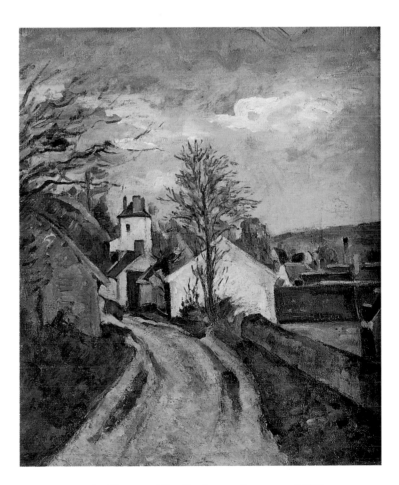

The House of Dr Gachet at Auvers, c.1873
Oil on canvas, 46 x 38cm
musée d'Orsay, Paris (gift of Paul Gachet)

in patches of colour, a technique that reminded Maurice Denis of the colours in a Persian carpet. Unlike Gauguin, Cézanne did not use areas of flat colour. He later told Émile Bernard: 'I have never wanted to accept nor will I ever accept the lack of shading or gradation. It makes no sense.'

By the early 1880s he had established his main range of subjects – Provençal landscapes with large trees; the Bay of Marseilles; Mont Sainte-Victoire; the Jas de Bouffan; still lifes with fruits; portraits and bathers. These themes are rendered in countless different ways, but never in a naturalistic way. Cézanne adopted a deliberately alienated approach. He gradually succeeded in organizing his feeling and in mastering his emotions, and after the early open air scenes of nudes steeped in an erotic atmosphere and his scenes of lovers' struggles and the temptation of St Anthony, his works become more tranquil. The figures are placed rhythmically in idealized landscapes and positioned according to geometric principles. Anecdotal images are rejected in favour of timeless and unidentifiable nudes, and the landscapes are empty of humans and animals. He showed the same detachment in his portraits, including those of his wife, Hortense Fiquet, who was almost his only female model. Her weary face, with its melancholy, faraway look, appears in many of his works. Cézanne's wish to control,

even to exclude entirely from his paintings, all overt sentimentality may be a reflection of the problems he experienced in resolving the emotional problems that arose within his family. He had for a long time been forced to submit to his father's will and he depended on him for financial support. He had hidden his liaison with Hortense and the birth in 1872 of their son, Paul, from his father, who heard of the events only by accident six years later. In a letter to Zola in 1891, Numa Coste, one of Cézanne's friends, commented: 'How can one account for the fact that such a hard, grasping banker could give birth to such a creature as our poor friend Cézanne?... He has become more timid, awkward and more child-like than ever.'

Of all the people around him, who seemed almost like characters from Balzac's' novels, only his mother showed him any love or support. In return, he loved her dearly, and when she died in 1897 he made one of the rooms of his apartment into a kind of shrine, filled with mementoes of her, which Hortense later destroyed in a fit of jealousy. For several years Cézanne confided all his family troubles and moral uncertainties to Zola, his childhood friend and companion, and they sometimes also discussed art. Their friendship came to an end, however, in 1886 with the publication of Zola's novel *L'Oeuvre* (*The Masterpiece*), the chief protagonist

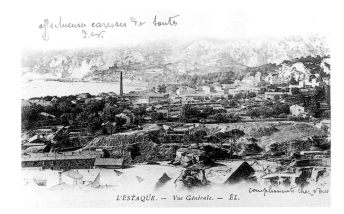

L'Estaque
Old postcard

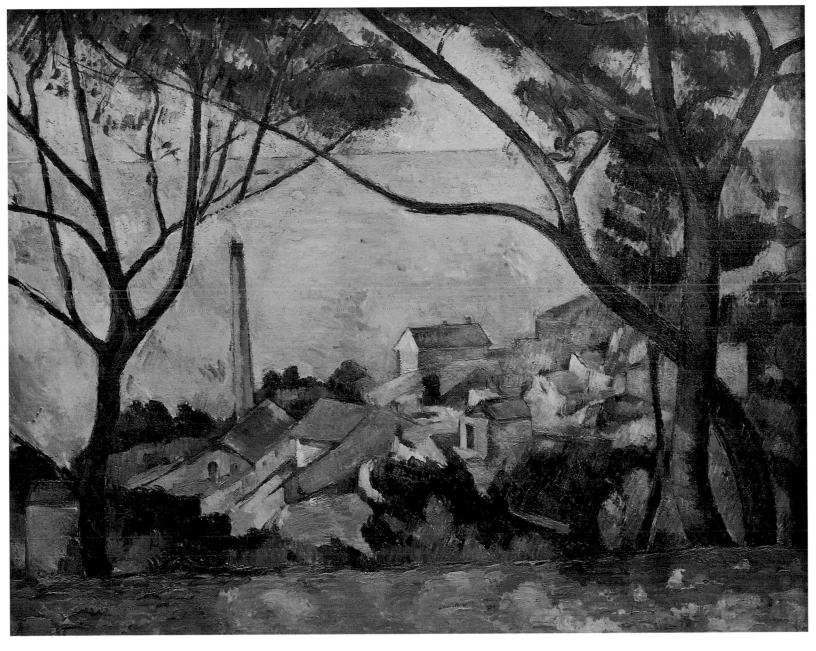

The Sea at L'Estaque 1883–1886
Oil on canvas, 73 x 92cm
musée Picasso, Paris

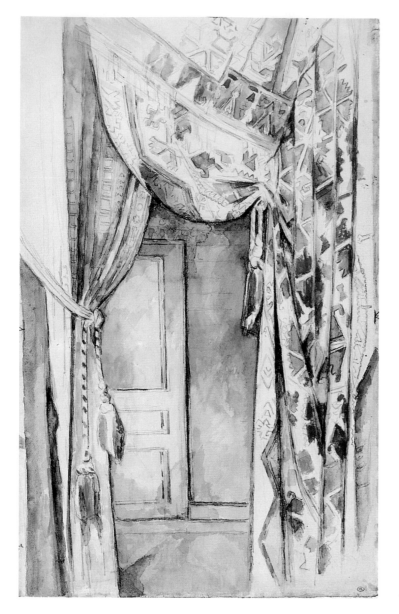

Study of Curtains, c.1885
Pencil, watercolour and gouache, 49 x 30cm
musée du Louvre, Paris
(Département des Arts Graphiques, Fonds Orsay)

where he drew study after study of works dating from ancient times to the eighteenth century, including works by Pigalle, Puget and Coysevox. Writing after Cézanne's death, Maurice Denis remarked: 'He liked the exuberance of movement, the impulsiveness of the hand and the boldness of the pencil line. ... He needed freedom and vehemence of execution. There can be no doubt that he preferred the affectation of the painters of Bologna to the precision of Ingres.' These morning sessions in the galleries of Paris served as warm-up exercises for his afternoon work in the studio or outdoors. He was trying to find a way of reconciling on his own canvases the lessons he learnt from the masters he admired – the Venetian painters, as well as Poussin and Rubens – and his own feelings for the subject he saw before him. He described this as wishing to 're-do Poussin over again according to nature.' His familiarity with the works of the old masters was his primary support in his work – in 1904 he described them as being like a 'plank for a swimmer.' Strengthened by his continuous studying and concentration on the works of the masters, his technique became increasingly rigorous.

During this period, while he was gradually developing his own style of painting, he led a somewhat secluded life. He refused for several years to show any of his work in public, and

of which was a failed painter who commits suicide, a character Zola had clearly based on Cézanne (and, to a lesser extent, on Manet).

Torn by family and personal conflicts, Cézanne divided his time between Paris and its surrounding countryside and the Midi. When he was in Paris he spent the morning in the galleries of the Louvre and the Trocadéro,

The Jas de Bouffan as it is today,
seen from the chestnut alley

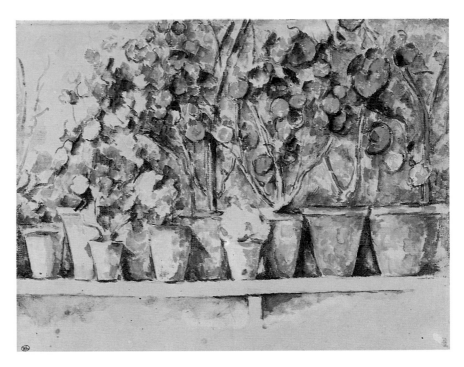

Pots of Flowers, c.1885
Pencil, gouache and watercolour, 23 x 30cm, musée du Louvre,
Paris (Département des Arts Graphiques, Fonds Orsay)

between 1877 and 1882 he did not contribute to any exhibitions, although a few of his works could be seen in Père Tanguy's shop. Tanguy was a dealer with premises in rue Clauzel, and Bernard later wrote: 'It was in his dark den that, for almost twenty years, Cézanne's work shone, like a hidden fire, and the whole of Paris went to seek them out.' Some critics, such as Roger Marx and Gustave Geffroy, had had their interest aroused in Cézanne's work by their artist friends, notably Monet, who had expressed their admiration for his work.

In 1889 Cézanne accepted an invitation from Octave Maus, the secretary of Les Vingts, to take part in their exhibition in Brussels. In his reply to Maus, Cézanne explained why he felt so isolated: 'The numerous studies at which I worked so hard led to no conclusive results. Therefore, dreading criticism, which would have

been completely justified, I decided to work in silence until the day came when I could successfully demonstrate the result to which my quest was leading me.'

Art is a harmony parallel to Nature

The mid-1890s marked a turning point in Cézanne's career. He had found the direction in which he wanted to work and was willing to put on public show what he still modestly called 'my studies.' Renoir had persuaded Ambroise Vollard, a young dealer who had recently opened a gallery on rue Lafitte, to take an interest in Cézanne's work, and towards the end of 1895 Vollard organized the first exhibition dedicated exclusively to Cézanne's works. Pissarro, Monet, Renoir and Degas were among those who not only went to the exhibition on

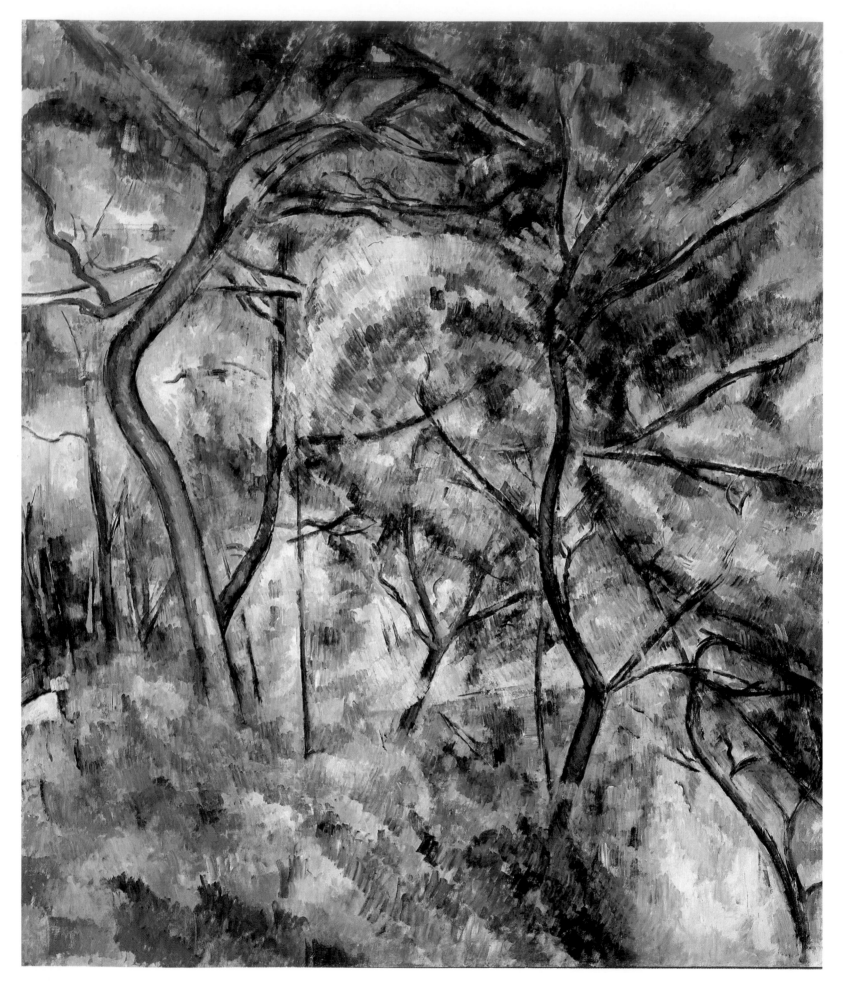

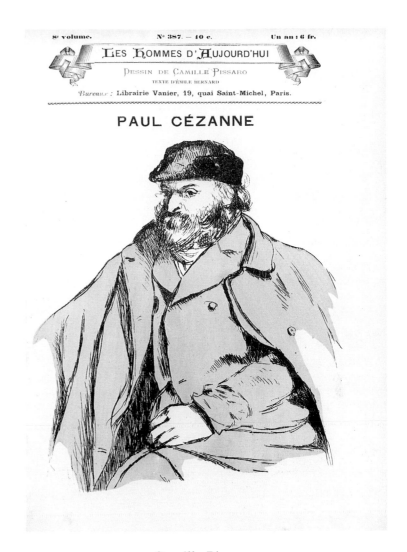

Camille Pissarro,
portrait of Paul Cézanne
Cover of *Les Hommes d'aujourd'hui*, May 1891

more than one occasion but who also bought both oil paintings and watercolours. New collectors were attracted by word of mouth and by the many reviews that appeared. Vollard's records reveal that nine oils, eight watercolours and a wash drawing were sold during the exhibition. However, far from being pleased with the success, which should have gone some way in reassuring him, Cézanne was irritated by the attention he was receiving. A few months later, in April 1896, he described his annoyance in blunt terms in a letter to Joachim Gasquet: 'I curse people like Geffroy [the art critic whose portrait he had recently abandoned] and those other mischief-makers who, for the sake of fifty francs, draw public attention to me in their reviews. ... How naïve I must have been to have imagined that it was possible to paint without exposing my private life to public view.' It is possible that his irritability and his violent mood swings were caused by the diabetes from which he had been suffering for some years.

After his mother's death in 1897, the Jas de Bouffan was sold, and Cézanne worked at several new sites, including the Château Noir and the quarry at Bibémus. These landscapes

Forest Interior, c.1882–1885
Oil on canvas, 116 x 81cm
County Museum of Art, Los Angeles

of forests and rocks were framed to give the impression that the subjects so completely filled the canvas that all the elements were fused together in the painted area. Patches of colour were built up methodically to create the image. The panoramic views of Mont Sainte-Victoire are kaleidoscopes of colour, in which the outlines appear and disappear in the shimmering light and air. The pyramidal shape of the mountain rises from the coloured magma as Cézanne creates the impression of the elements before they formed the landscape visible today. He

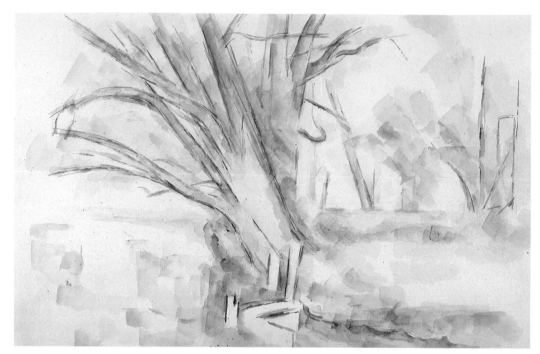

*Leafless Trees on a River Bank, c.*1902
Watercolour, 31 x 49cm
Mr and Mrs E.V. Thaw Collection, New York

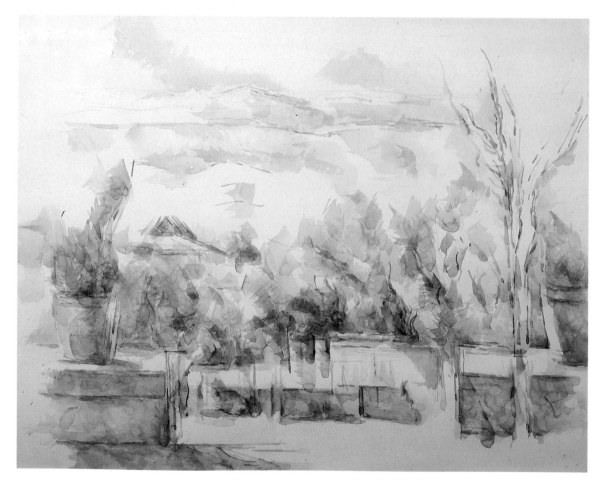

Garden Terrace at Les Lauves,
1902–1906
Pencil and watercolour, 41 x 52cm
Mr and Mrs E.V. Thaw Collection,
New York

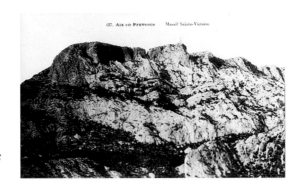

Mont Sainte-Victoire
Old postcard

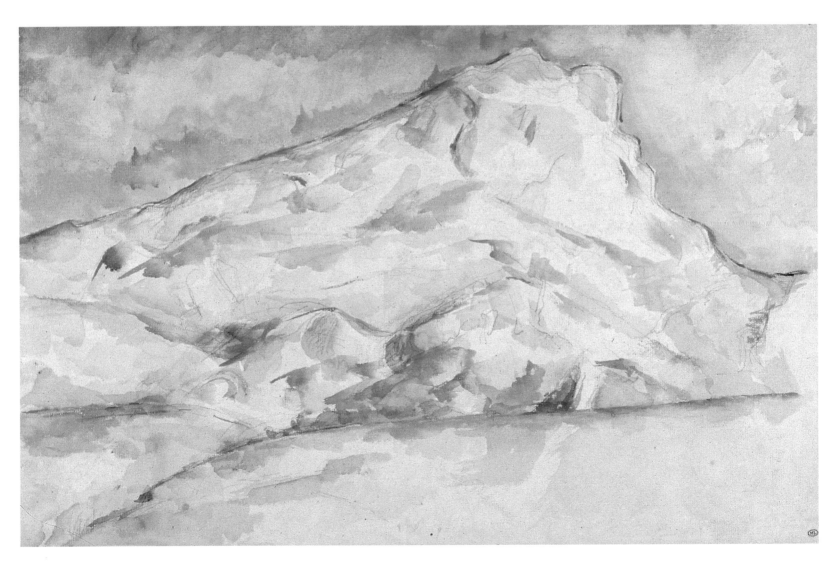

Mont Sainte-Victoire, 1900–1902
Watercolour, 31 x 47cm
musée du Louvre, Paris (Département des Arts Graphiques, Fonds Orsay)

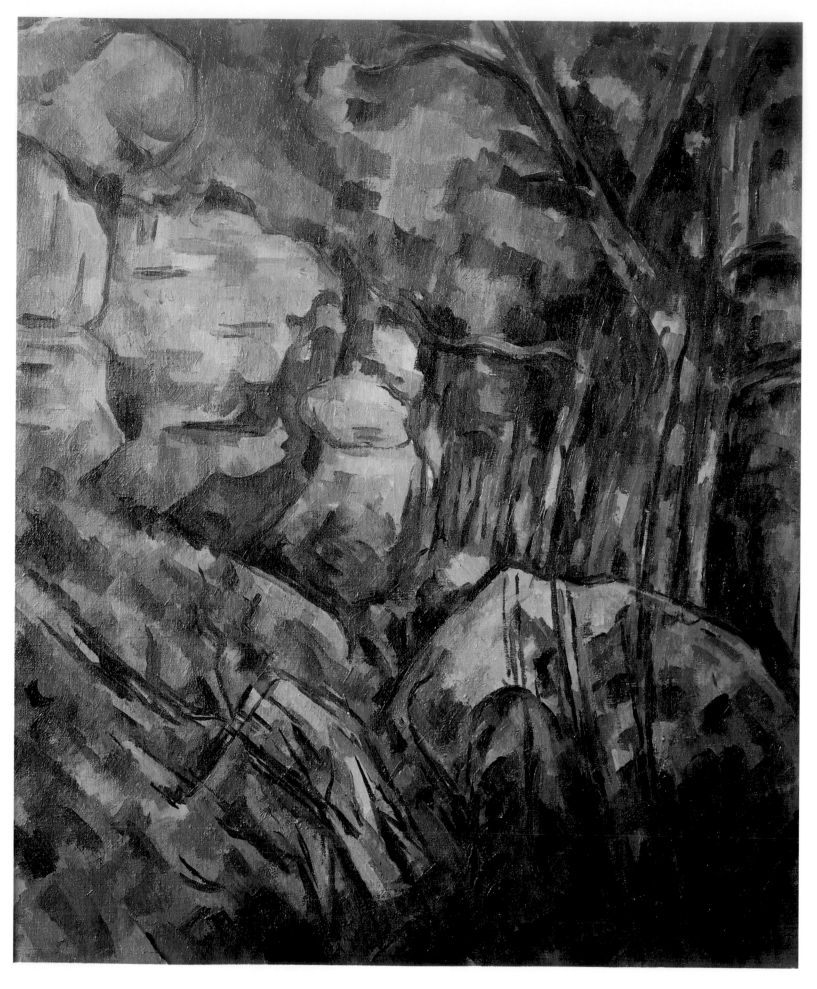

concentrated on organizing the subject matter on the canvas through a technique that did not depend on a descriptive vision but that was not, at the same time, non-referential. Although he broke down the subject into coloured planes, he did not ignore the third dimension – volume – and, as he explained in a letter to Bernard, he established a system of colour equivalence that allowed him to translate visual sensations into gradations of colour. Returning constantly to the same subjects, he was able to scrutinize them over a long period. When he was an old man he said to Vollard: 'The outline escapes me.'

In addition to oil paintings, he produced many watercolours, a medium he used with great skill. He would lay areas of translucent colour on a preliminary drawing, but instead of covering the entire paper, he left spaces between the coloured areas, and these brought light into the compositions. It is clear from these works that Cézanne did not restrict colour to the confines of the preliminary contours, and he later applied this technique to his oil paintings.

In the early 1890s a new theme became apparent in his works when he started to paint card players in an interior setting. The format of

*Rocks near the Caves above Château Noir, c.*1904
Oil on canvas, 65 x 54cm
musée d'Orsay, Paris (Henri Matisse Collection)

these compositions ranged from huge works, in the style of Courbet's *After Dinner at Ornans*, to intimate scenes, in the manner of Flemish interiors. As models for these works he used gardeners, farm labourers and peasants who worked at the Jas de Bouffan.

Bathers were another subject that became increasingly important to him in his later years, although he had worked on these intermittently throughout his life. Cézanne was composing large-scale works in which he wanted to paint nudes in a landscape without an underlying literary theme. He did not, however, paint from life. Having had problems with finding models in Aix and being aware of the impossibility of their posing in the open, he was forced to resort to a number of compromises.

Émile Bernard tells us that Cézanne was oppressed by a sense of decency. According to Bernard, the artist did not trust himself in the presence of women, while his religious scruples and sense that one should do nothing that would scandalize the inhabitants of a small provincial town further thwarted his ambitions in this direction. Cézanne had no particular interest in the verisimilitude of the scene he was painting, rather, in Rewald's view: 'It is a world unto itself, in which objects and the intervals between them are immediate data from which an assemblage of questions about the imaginary have to be set up

in accordance with the conceptual structure of a new world.'

All the elements within this world – the trees, figures, air and water – are reduced to the same level of significance and translated by means of an intricate network of interrelating coloured shapes, which combine, by means of the meticulous quasi-musical and analytical study of colours into tones, semi-tones and quarter-tones, to produce an equilibrium. Cézanne found a deep echo of his artistic feelings in Baudelaire's lines:

Comme de longs échos qui de loin se confondent
Dans une ténébreuse et profonde unité.
Vaste comme la nuit et comme la clarté,
Les parfums, les couleurs et les sons se répondent.

('Like dwindling echoes gather far away,/Into a deep, dark unison,/Vast as night or the light of day,/Perfumes, sounds and colours answer each to each.')

Painter and poet were united in their admiration for Delacroix. Only a month before his death Cézanne re-read Baudelaire's art criticism with enthusiasm. In a letter to his son he said: 'What a powerful writer, that Baudelaire. His *Art romantique* is great, and he is absolutely right about the artists he appreciates.' Two years earlier, Cézanne had been planning to compose a work to honour Delacroix, whom many regarded as the leader of Romanticism,

and in his youth he had dedicated a work to that painter.

The colour-space of an apple,
The space burnt out by a fruit dish.

By the end of the nineteenth century Cézanne's painting was finally being recognized in Paris and elsewhere. Interest had been aroused by the retrospective organized by Vollard in 1895, and it was nourished by two other exhibitions in 1898 and 1899. By the end of the century art lovers in France and other countries could find his work in the galleries of Vollard, Durand-Ruel and Bernheim-Jeune and in 1899, 1901 and 1902 at the Salon des Indépendants. He was also represented at the 1900 exhibition celebrating the Centenary of French Art and at the Salon d'Automne in 1904, 1905, 1906 and 1907, when a posthumous, retrospective exhibition showed fifty-six of his works. The first of Cézanne's paintings to be shown in a public gallery abroad was bought by Hugo von Tschudi for the National Gallery of Berlin in 1897, at the very moment when the Caillebotte Bequest of Impressionist paintings, which included four of Cézanne's works, was creating a scandal in France. Cézanne was alarmed by the attention his paintings were attracting, and he sought refuge in the south of France to pursue his work in peace. There, in his

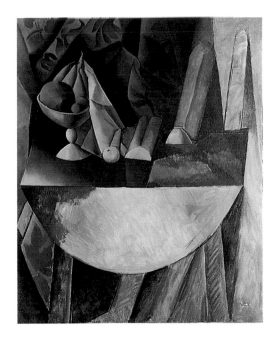

Pablo Picasso, *Still Life with Bread and Bowl of Fruit on a Table*, 1909
Oil on canvas, 164 x 132cm
Kunstmuseum, Basle

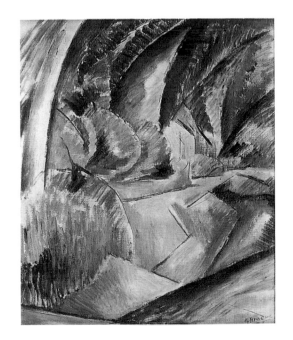

Georges Braque, *Road at L'Estaque*, 1908
Oil on canvas, 46 x 38cm
Musée National d'Art Moderne,
Centre G. Pompidou, Paris

modest retreat, he was visited by young painters who came to ask his advice or to show their sincere admiration. He told them he wanted to remain an 'artisan' in painting, like the early masters, the picture-makers of the Middle Ages. 'I am the primitive of the way I have found,' he declared.

Now it is a commonplace that Cézanne's art is to be regarded as the starting point of the revolution in painting that was taking place in Paris at the beginning of the twentieth century. His handling of space and his well-known statement concerning the need to render 'nature by means of the cylinder, the sphere and the cone, all put in perspective' have often been cited to justify the Cubist revolution. Braque and Picasso sometimes pursued, almost to the point of caricature, the process of deconstruction of an object that was the aim of the older

man. As Robert Delaunay pointed out: 'The revolution was in the breaking down [into pieces], which we had already glimpsed in Cézanne's fruit dish and in his watercolours. ... The object broken down in this way cannot be put back together.'

Even though Cézanne's art seems to aspire, in the words of L. Brion-Guerry, to express 'the hereafter of the object or the figure,' it never broke away from the perceived image of the subject nor from the expression of its depth. The Cubists produced a many-faceted interpretation of their chosen subject matter, taking the viewer's eye around it. In Cubist works dating from 1907 to 1909 there are numerous references to Cézanne's favourite themes – views of L'Estaque, bathers, Harlequin and bowls piled high with fruit. Fernand Léger, who had discovered Cézanne at the Salon d'Automne in 1904

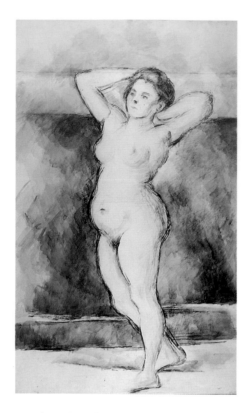

Standing Woman in the Nude,
1898–1899
Pencil and watercolour, 89 x 53cm
musée du Louvre, Paris
(Département des Arts
Graphiques, Fonds Orsay)

and in the retrospective exhibition in 1907, declared that his own love for shape and volume derived from Cézanne. He explicitly honoured the painter in his 1909 painting, *Fruit Stand on a Table* and in his 1917 work, *The Card Players*. Picasso, who was also touched by certain objects through which he sought to decipher the mystery of creation, admired Cézanne's determined quest as much as his method. 'It is not,' he remarked, 'what the artist does that counts but what he is. ... What we are interested in is Cézanne's quest, Cézanne's lesson.' This lesson, transmitted directly to us through Cézanne's works or as it was translated by the Cubists, travelled throughout Europe and reached Moscow, where it was revealed to Russian painters in the exhibition 'The Knave of Diamonds' in 1910. Cézanne's impact affected not only those artists who felt passionately about form and volume, but also the colourists.

Picasso, Braque and Derain belonged to the same generation as Matisse, who wrote: 'You cannot imagine the moral strength and encouragement that his wonderful example provided all my life. Whenever I doubted myself or was frightened by my discoveries, I thought

"If Cézanne is right, I am right," and I knew that Cézanne was not mistaken.' Matisse was inspired by Cézanne's construction and by his 'architectural laws.' He owned no fewer than four of Cézanne's paintings, including *Three Bathers* (*c.*1879–1882), which he considered to be a treasure, a masterpiece. He found it an inexhaustible work, into which all the other bathing scenes were condensed. 'It has raised my spirits at critical moments of my artistic life. I have drawn faith and perseverance from it.'

The watercolours of Cézanne's last years, with their juxtaposed strokes dissociated from the underlying drawing, have within them the germ of a new style of painting, in which the subject is replaced by form, colour and movement. Delaunay and Picabia also pursued 'the idea of painting that would, technically speaking, owe everything to colour and colour contrasts, but expanding in time and capable of being seen in a single glance.' Cézanne believed in transcendence, the hereafter of form and matter. His painting reached the essence of art, its spiritual nature, as Kandinsky noted: 'He tried to discover new evidence of shapes... through the use of exclusively pictorial means. He turned a cup of

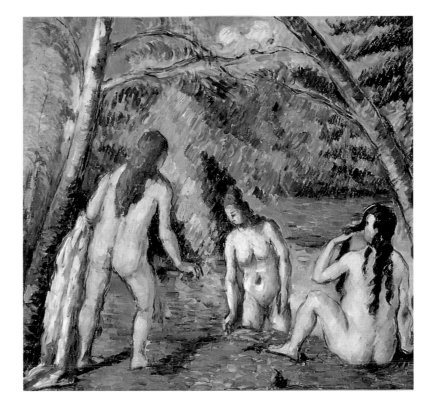

*Three Bathers, c.*1879–1882
Oil on canvas, 53 x 55cm
musée du Petit Palais, Paris
(This painting belonged to Henri Matisse)

tea into a being with a rich soul or, rather, he found the being in that cup. He raised the still life to the rank of an object with a lifeless exterior but a living interior. He treated objects in the same way as he treated people, for he had the gift of discovering the inner life of everything. He took them and gave them colour, and they became alive with an inner life, but in an essentially pictorial way. He reduced them to a shape that was reducible to abstract, often mathematical formulae, from which emanated a radiant harmony.

'What [Cézanne] meant to do was neither to represent man, nor apple, nor tree, but rather he used all these to create something painted that has a deep, inner resonance and that is called its image.' Paul Klee, who discovered Cézanne's works in 1908 and 1909, was inspired to coin his aphorism: *L'art ne rend pas le visible, il rend visible.* ('Art does not simply imitate the visible, it renders the visible.')

By removing from painting its predominantly descriptive and imitative role, Cézanne initiated a new theory, according to which art may be considered a system of signs. His influence was predominant before the First World War and it affected artists as different as Kandinsky, Klee, Mondrian and Duchamp.

Cézanne may have had a premonition of the impact his work would have on the generations that would follow him. It is evident that, despite his self-deprecatory protestations, he was absolutely clear about this mission.

In a prophetic vision Cézanne saw himself as Moses, chosen by God to guide the righteous, and even though the outcome may have been unclear to him, he nevertheless expressed to Vollard his long-held ambitions in these heartfelt words: 'I am working with determination, and I glimpse the promised land. Will I be like the great leader of the Hebrews or will I be able to enter into it? I have made some progress, but why was it so late and achieved at such cost? Is it because art does, indeed, require the total dedication – body and soul – of those who commit themselves to it?'

Still Life with Bread and Eggs

CÉZANNE SPENT most of 1865 in Paris, where he continued his training, working on life studies at the Atelier Suisse in the mornings and, in the afternoons, visiting galleries where he studied the works of the old masters he admired. The Spanish school of painting was in vogue during the Second Empire, and Zola commented on its role in the development of Cézanne's style. In 1865 Marius Roux, in an article about the artists from Aix-en-Provence who formed part of Zola's circle, noted: 'M. Cézanne is one of the good pupils who is come to Paris from Aix. ... A great admirer of Ribeira [sic] and Zurbarán, our painter's art nevertheless springs entirely from within himself.' This influence may be seen in the choice of deliberately mundane objects for this still life and in the black background, with its trace of blue, against which the table on which the objects are placed is scarcely visible. Cézanne's tenebrism developed from the realism

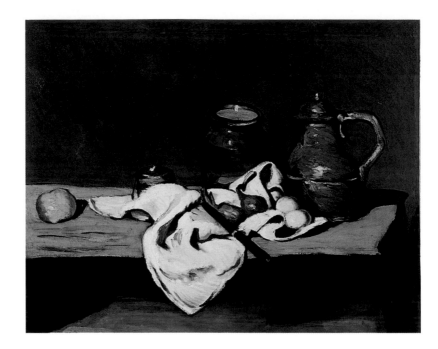

Still Life with Pewter Jug, 1869–1870
Oil on canvas, 64 x 81cm
musée d'Orsay, Paris

of such painters as Bonvin and Ribot, who were, in turn, influenced by Courbet and who, like Cézanne, were deeply affected by the still life tradition of Spain. Apart from the amber of the bread, the reddish colour of the onions and the blue of the pewter pot, the composition is executed entirely in various tones of black and white. The main element, the bread, stretches horizontally across the canvas, and the only vertical lines are those of the glass and the pewter pot. Depth is suggested, in the classical fashion, by the diagonally positioned knife. Despite the basic conservatism of the composition, this still life was rejected by the jury of the 1866 Salon. Cézanne's disappointment was assuaged somewhat by an encouraging comment from Manet, who had seen Cézanne's still lifes at Guillemet's. Guillemet noted that: 'Manet thought that the treatment showed great strength. Cézanne was greatly encouraged by this comment.'

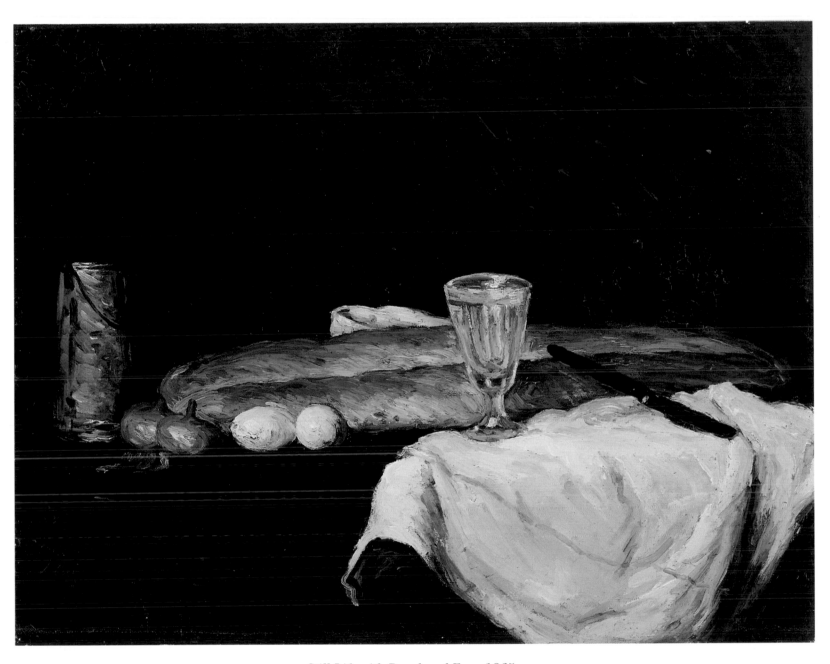

Still Life with Bread and Eggs, 1865
Oil on canvas, 59 x 76cm
Cincinnati Art Museum, Cincinnati, Ohio
(Gift of Mary E. Johnston)

The Black Clock

ON 20 MAY 1866 Zola published in book form a series of seven articles about the Salon that had previously been published in *L'Evénement*. The book bore the fulsome dedication: 'To my friend Paul Cézanne... You are all my youth; you are part of all my joy and all my suffering. Our minds, having so much in common, developed side by side. Today we seem to be at a new beginning. We have faith in ourselves because we have seen through our hearts and our bodies.' This warm dedication marks the end of a period in which the two young men indulged in a somewhat romantic dream of living for their art and conquering Paris. In fact, in 1866 Zola was on the point of achieving success. The following year he took up his pen to defend Manet in a pamphlet entitled 'A New Manner of Painting: M. Édouard Manet.' By way of thanks, Manet painted Zola's portrait, showing the writer at his desk, surrounded by the usual paraphernalia of pens and books, with the recently published pamphlet in a prominent position, and reproductions of works of art, notably *Olympia*.

In his 1867–69 portrait of Zola, *Paul Alexis Reading at Zola's House*, Cézanne had included a black clock surmounted by a statuette, and he embarked on this new still life at his friend's home in rue de la Condamine, Les Batignolles. The painting is a tribute to the writer, to whom Cézanne gave the canvas probably as a friendly gesture in response to the earlier dedication. Allusions to Manet's work, which Cézanne admired, are evident in the white cloth, with its well-defined folds, and the lemon – 'borrowed' by Manet from Flemish still lifes – which adds a bright, acid touch. With its carefully arranged elements and the mirror, positioned in the background for spatial effect, it is almost as if in this still life Cézanne was seeking to prove to Zola, who may still have harboured some doubts, how talented he was.

The painting may also be seen as a symbolic portrait of the writer. The black marble clock and the inkstand, which were also present in Manet's portrait, represent Zola's hardworking nature. A few years after this canvas was completed

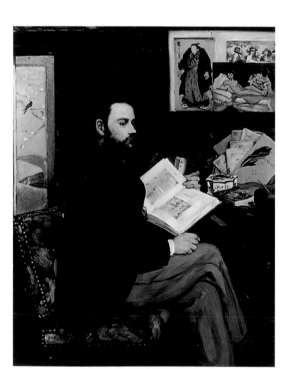

Édouard Manet, *Émile Zola*, 1868
Oil on canvas, 146 x 114cm
musée d'Orsay, Paris
(Gift of Mme Émile Zola)

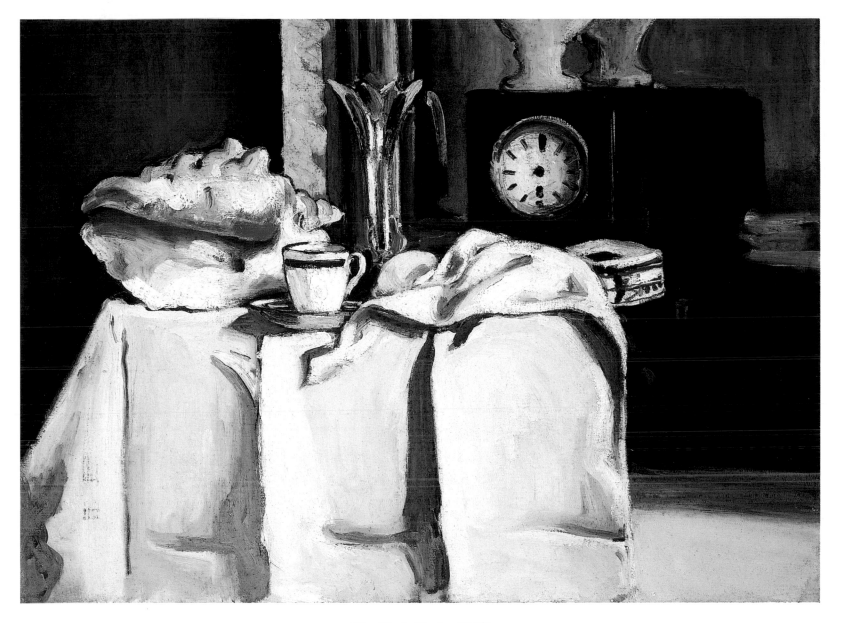

*The Black Clock, c.*1867
Oil on canvas, 55 x 74cm
Private collection

Zola had Pliny the Elder's epigram *Nulla dies sine linea* ('not one day without a line') inscribed above the fireplace. The shell, with its carmine mouth towards us, may symbolize Zola's effeminacy, a reading that is suggested less explicitly in other paintings by Cézanne. The shell, the only baroque and sensuous note in this otherwise sombre, almost monochromatic composition, is a dramatic contrast to the plain black clock, which, with no hands to tell the time, symbolizes eternity or, perhaps, a friendship that Cézanne thought would be everlasting.

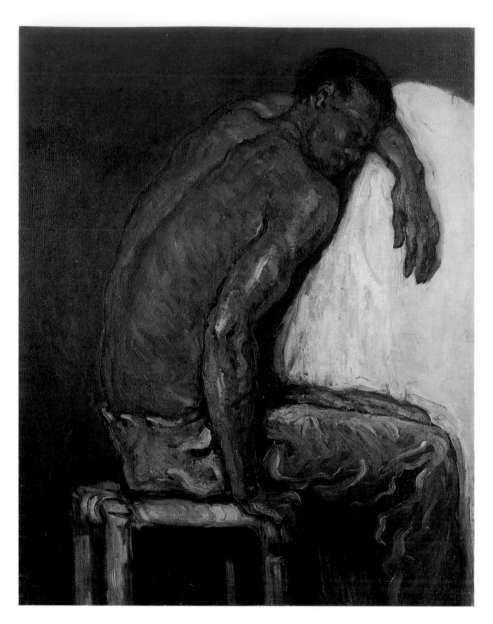

The Negro Scipio, c.1867
Oil on canvas, 107 x 85cm
Museu de Arte, São Paulo

The Negro Scipio

AFTER HIS FIRST over-finished studies of the nude, which he had produced under the supervision of his teacher at the School of Drawing in Aix-en-Provence, Cézanne painted freer studies of the human form at the Atelier Suisse, where he began painting in 1861 and where Scipio was a model.

The elongation of the model's torso, thighs and left hand create a monumental impression. The huge, muscular back is achieved by thick strokes worked in the wet paint. The play of light on the dark skin offers scope for a wide range of colours: beige, reddish-brown, orange and green. The dark outline accentuates the highlights and planes of the spectacular frame. The strong, almost aggressive presence of the model's body contrasts with his 'non-presence' – Scipio slumps (probably in the artist's studio) while his body is subject to the whims of the artist's brush or palette knife. The sinuous stokes and the treatment of the subject, all curves and counter-curves,

give a baroque rhythm to this sombre composition.

A comparison with *Mary Magdalene*, a large work painted by Cézanne during the same period, bears out the suggestion that *The Negro Scipio* may have been the inspiration for the painting now in the musée d'Orsay. Both show a figure in a similar position and have the same colour range – blue clothes, a dark background and a large light area to the right. However, while the figure of Mary Magdalene is an expression of despair and sorrow, Scipio appears merely to be a study in anatomy, with, unusually for the 1860s and 1870s, no underlying narrative.

The Negro Scipio belonged to Monet, who owned thirteen other works by Cézanne. He kept it in his bedroom with his favourite paintings, for he considered it to be *un morceau de première force* ('a work of the greatest strength').

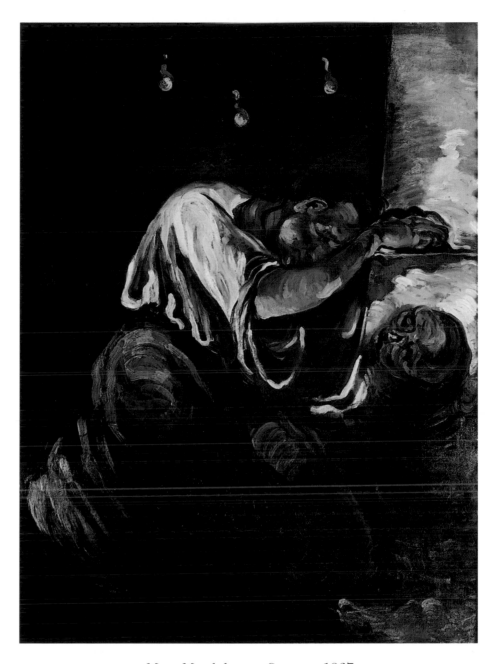

Mary Magdalene or *Sorrow*, c.1867
Oil on canvas, 165 x 124cm
musée d'Orsay, Paris

The Abduction

ALTHOUGH IT IS AN OUTDOOR SCENE, with hills reminiscent of Mont Sainte-Victoire in the background, this work, also known as *The Rape* and treated in the classical manner, seems to have been painted at Zola's house in the rue de la Condamine.

The subject matter owes more to the artist's imagination and knowledge of myths than to any reality. The title usually given to the painting, *The Abduction*, was not used by Cézanne. It appears for the first time in the catalogue produced for the sale of Zola's estate, of which it was part. A recent study by Peter Kropmanns suggests that it is a representation of an episode in the life of Hercules, probably influenced by Delacroix's compositions for the Salon de la Paix at the Hôtel de Ville, Paris. It may show Hesione freed by Hercules from the chains that bound her as a sacrifice to a sea-monster. Instead of depicting the critical moments of the rescue and the danger threatening Hesione, Cézanne chose instead to show the following, calmer

The Abduction, detail

episode of the story. The unconscious heroine is carried to safety by Hercules, while in the distance nymphs beside the river observe the scene impassively. Alternatively, the painting may represent the episode when Hercules rescues Alcestis from the Underworld and carries her back to her grieving husband Admetus. This event was also illustrated by Delacroix in his works for the Salon de la Paix.

This mixture of iconographic references for both subject and form is typical of the young Cézanne's syncretic methods, by which he retained complete freedom while appropriating the influences of the painters he admired, Delacroix and also, as may be seen in the large strokes used for the landscape and the vigorously treated figures, Courbet and Daumier.

In the work all traditional features are stripped away in the representation of a dramatic absolute: the contrast between the vigorous configuration of the man's body and the apparently lifeless form of the woman.

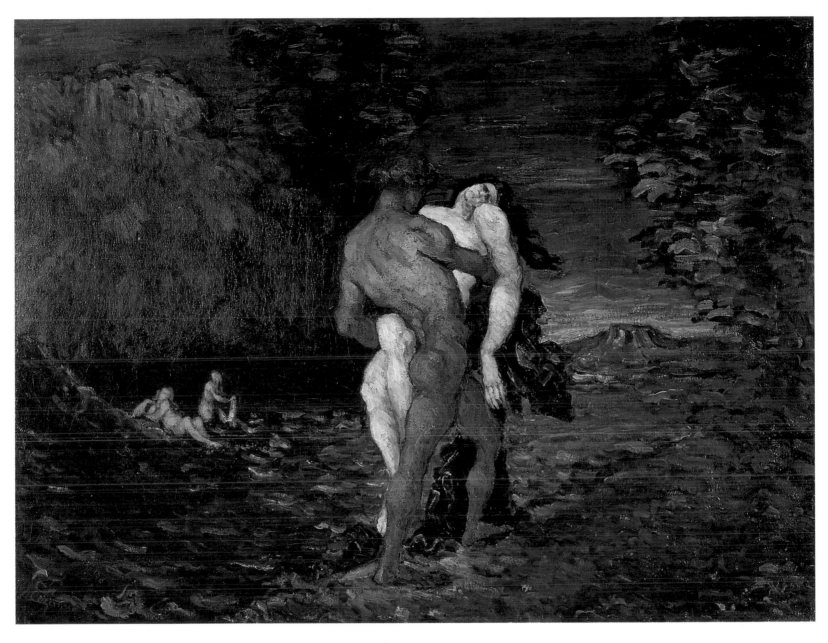

The Abduction, 1867 (also known as *The Rape*)
Oil on canvas, 90.5 x 117cm
Keynes Collection, The Provost and Fellows of King's College, Cambridge
(In trust at the Fitzwilliam Museum, Cambridge)

Young Girl at the Piano – Overture to Tannhäuser

T̲HE GERMAN MUSICIAN Henri Morstatt, who lived in Marseilles between 1864 and 1867, probably introduced Cézanne to Wagner's music. The two young men met through Fortuné Marion, and at the end of December 1865 Cézanne invited Morstatt to the Jas de Bouffan to play some Wagner as part of the Christmas festivities.

Long before January 1868, when he had heard the overtures to *The Flying Dutchman* and to *Tannhäuser* and the prelude to *Lohengrin* in Paris, Cézanne had begun the first of his compositions inspired by the composer. On 28 August 1866 Marion wrote to Morstatt: 'In one morning he has half-created a splendid painting, you'll see. It will be called *The Overture to* Tanauhser [*sic*]. It is futuristic, like Wagner's music. It is like this: a young girl is at the piano; white on blue; right in the foreground. The piano is treated in a large, masterful way; an old man, sitting in an armchair, is seen in profile; a small child

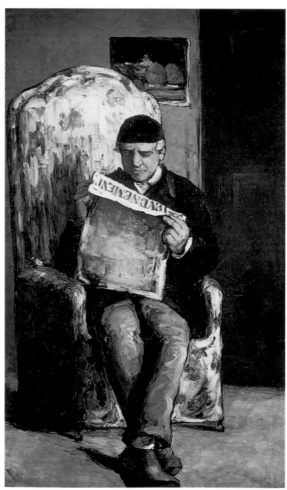

Louis-Auguste Cézanne Reading L'Evénement, 1866 Oil on canvas, 200 x 120cm
National Gallery of Art, Washington D.C.
(Mr and Mrs Paul Mellon Collection)

with an idiotic look listens in the background. The effect is wild and overwhelmingly powerful; it has to be looked at for a long time.' According to a letter from Antoine Guillemet to Zola dated 2 November 1866, this now lost work was based on a representation of a family evening.

Cézanne turned again to the subject, but this time he greatly changed the colours and the figures. The scene shows the family sitting-room, where the absent father is symbolized by the large, empty armchair on the right. It is the same armchair in which Cézanne's father had posed in 1866 (*Louis-Auguste Cézanne Reading* L'Evénement) and that is seen again in *Portrait of the Painter Achille Emperaire* (see page 48). Cézanne's younger sister, Rose, who was then about fifteen years old, is playing the piano while the other sister, Marie, who was twenty-six (not the artist's mother, as has often been suggested), appears in the background doing some needlework.

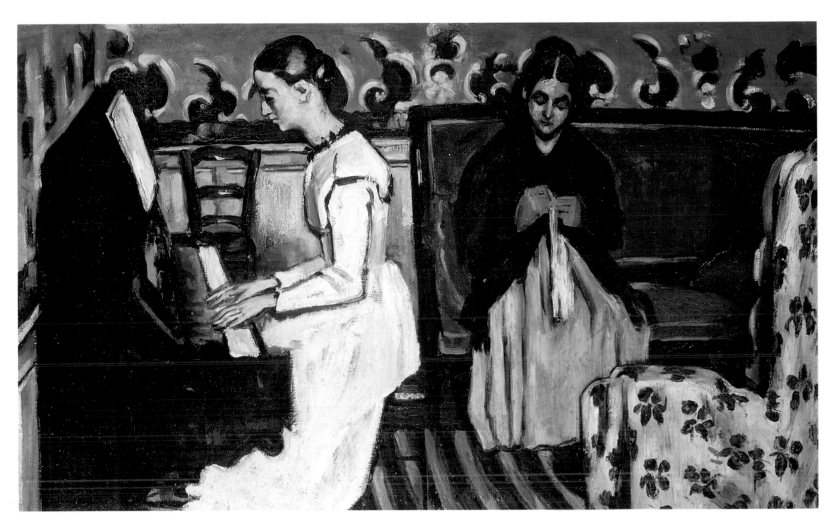

Young Girl at the Piano – Overture to Tannhäuser, 1867–70
Oil on canvas, 57 x 92cm
Hermitage Museum, St Petersburg

Cézanne intended the work – although without much hope of success – for the Salon, but, as usual, it was rejected. After the selection results were known, Marion made his disappointment known to Morstatt: 'Realist painting today... is... further than ever from succeeding in the Establishment, and it will definitely be a long time before Cézanne is able to exhibit his work among the officially sponsored and protected artists. His name is already too well known and he is associated with too many revolutionary artistic ideas for the members of the selection committee to weaken for a single instant. I admire Paul's perseverance and *sang-froid* when he writes to me: "Oh well! We'll go on throwing works at them for ever with greater and greater determination."'

Portrait of the Painter Achille Emperaire

CÉZANNE MET the Aix-born painter Achille Emperaire (1829–98) not in the south of France but at the Atelier Suisse, where they were both working on life studies. A penniless artist with an ungainly physique, Emperaire was helped by his fellow southerner on more than one occasion, and by painting this monumental portrait of him, Cézanne transformed the poor outcast into an heroic figure, in much the same way that Velazquez's paintings of dwarfs had done. The painting was refused by the selection committee of the Salon in 1870. At once naïve, ingenuous and theatrical, the work is a celebration of the character of the subject and of his pathetic fate.

It was justly described by a mutual friend, Joachim Gasquet: 'A dwarf, but with a magnificent head, like one of van Dyck's cavaliers, with a fiery soul and nerves of steel. With an iron pride within a deformed body, the flame of genius burns in a misshapen hearth, like a combination of Prometheus and Don Quixote. ... He [Cézanne] has painted an astonishing portrait of Emperaire, with the dwarf's heavy head standing out from red flowers of the upholstery, the legs, too short to reach the ground, resting on a foot warmer. Wrapped in his robe, the slender figure has just come out of the bath. Emaciated, like a caricature, exasperated and overwhelmed with the effort of living, pathetic, the long hands dangling, his beautiful, pain-worn face appears to be attached to the armature of a tragic will; and above him, like an ironic label, Cézanne has inscribed in large letters the name "Achille Emperaire".'

This work, part burlesque, part dramatic, is one in a series of portraits for which his relations were models. In one, his father is seen sitting in the same armchair as Achille, reading *L'Evénement*. In another, his maternal uncle Dominique Aubert is fantastically dressed as a barrister or a monk, wearing an Arab cloak and a turban or a cotton cap.

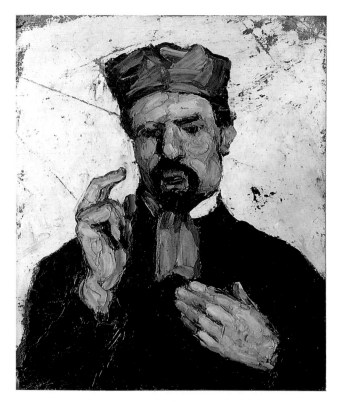

Uncle Dominique or *The Lawyer, c.*1866
Oil on canvas, 63 x 52cm
musée d'Orsay, Paris

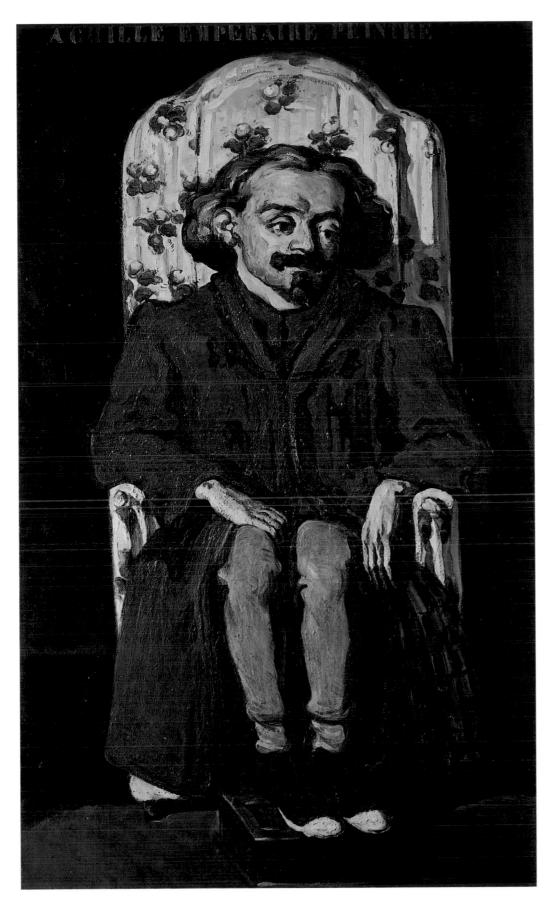

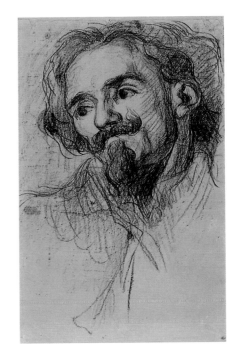

Achille Emperaire
Charcoal and pencil on
paper, 49 x 31cm
musée du Louvre, Paris
(Département des Arts
Graphiques, Fonds Orsay)

Portrait of the Painter Achille Emperaire,
1869–1870
Oil on canvas, 200 x 120cm
musée d'Orsay, Paris

Paul Alexis Reading to Émile Zola

DURING THE MID-1860s, while he was still painting small canvases, Cézanne also executed some large compositions, which he probably intended for the Salon. In 1868 he planned to paint a group of his friends, talking to each other, in a landscape. This was to have been a large, realistic painting, which he would have given to the Marseilles Museum, but it did not materialize. Instead, Cézanne confined himself to more intimate groups with a limited number of figures – Marion and Valabrègue and, twice, Zola being read to by a friend. Paul Alexis, seen sitting in a garden chair on the left of this painting, came from Aix, and he was a close friend of Zola's, although he was seven years younger. He had arrived in Paris in 1869 and devoted himself to writing, publishing poems and novels and, in 1882, the first biography of Zola, *Émile Zola, notes d'un ami*.

In Cézanne's painting Alexis is probably reading from one of his manuscripts in the garden of Zola's house in the rue de la Condamine. Cézanne had himself already

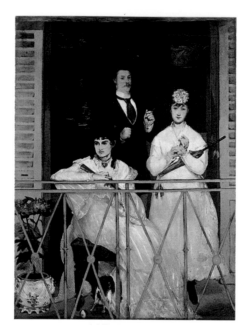

Édouard Manet, *The Balcony*,
1868–1869
Oil on canvas, 170 x 124cm
musée d'Orsay, Paris
(Gustave Caillebotte Bequest)

experienced such an event at Aix, as he told a mutual friend, Numa Coste, in July 1868: 'Alexis was kind enough to read to me some of his poetry, which I thought was very good.' Zola is on the right of the painting, seated on a rug laid on the lawn and resting his elbow on a cushion. This section of the painting, unfinished apart from the face, is built up with broad brush strokes. Many features in the double portrait are reminiscent of Manet, particularly the treatment of the blacks and the Japanese-like positioning of the elements of the composition, with the tight centring and high point of view. The green shutter of the French window recalls the use of a similar motif in Manet's *The Balcony*. Zola, to whom the painting was given, relegated it to the attic of his house in Médan, where it was found after his death. The outbreak of the Franco-Prussian War in the summer of 1870 may have led Zola to store the painting in his attic, or he may have done this when his friendship with Cézanne ended following the publication of *L'Oeuvre* in 1886.

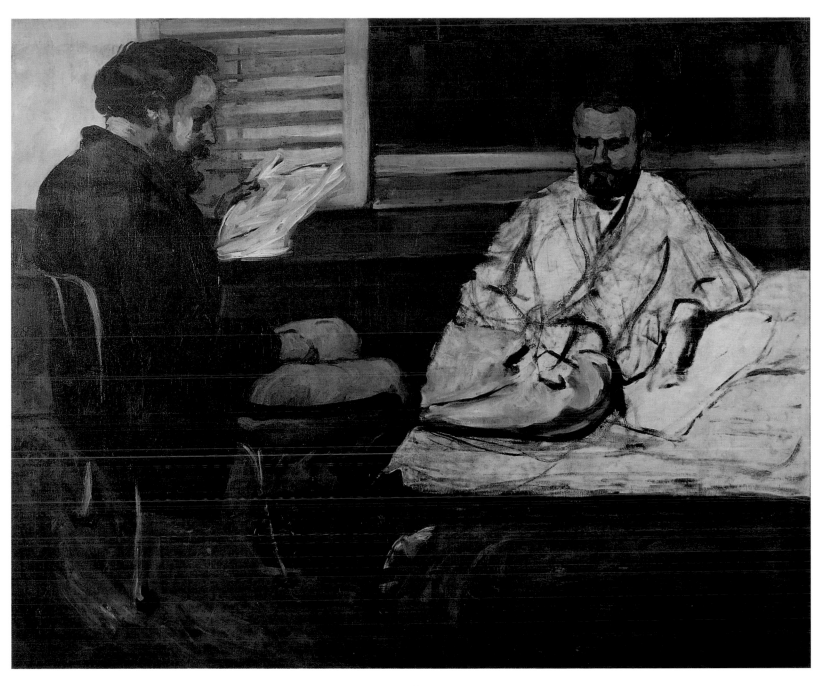

Paul Alexis Reading to Émile Zola, 1869–1970
Oil on canvas, 130x 160cm
Museu de Arte, São Paulo

The House of the Hanged Man at Auvers-sur-Oise

CÉZANNE, HORTENSE and their one-year-old son spent the whole of 1873 at Auvers-sur-Oise, a small village in the Ile-de-France. While they were there, Cézanne again met Dr Gachet, who was a friend and collector of the Impressionists as well as an old acquaintance of Cézanne's father. Dr Gachet introduced Cézanne to the art of etching.

The village also had the advantage of being close to Pontoise, the home of 'the humble and colossal Pissarro,' with whom Cézanne painted. In the surrounding countryside he painted both panoramic views and village scenes. He lightened the tonal range of his palette but had not yet entirely given up the technique, typical of his first period, of modelling the subject directly in wet paint. Towards the end of his life he explained this to Maurice Denis: 'It is because I cannot render my feelings at the first attempt, so I add on paint; then I add more. When I start I always try to paint with solid paint like Manet, modelling it with a brush.' The impasto of *The House of the Hanged Man* shows this laborious process of completing a composition. The

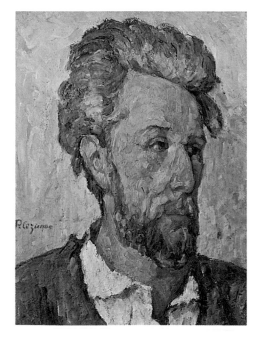

Portrait of Victor Chocquet, 1876–1877
Oil on canvas, 46 x 36cm
Private collection

same clotted rendering can also be found in the still lifes of this period.

Théodore Duret related that the gloomy name given to the house, which was probably painted in the spring of 1873, 'arose from the fact that the master of the house had committed suicide in it.' Cézanne was more circumspect about the matter when he wrote to Count Doria about the painting on 30 June 1889: 'It is the name given to one of the landscapes that I painted in Auvers.' In fact the title appears for the first time in the catalogue of the 1874 Impressionist exhibition, where the canvas was shown. The painting was bought by Count Doria – it was the first painting Cézanne had sold – before passing into Victor Chocquet's collection. Exceptionally, the painting was exhibited twice more during Cézanne's life – in the 1889 exhibition celebrating the Centenary of French Art and at the exhibition of Les Vingts in Brussels in 1890. The Surrealist André Breton, writing in 1937, thought he could detect a sense of evil in the composition of the painting. '*The House of the Hanged Man* in particular has always

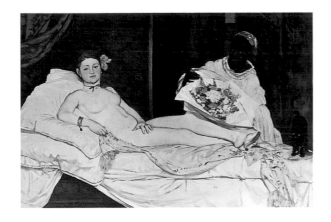

Édouard Manet, *Olympia*, 1865
Oil on canvas, 130 x 190cm
musée d'Orsay, Paris

A Modern Olympia 1873–1874
Oil on canvas, 46 x 55cm
musée d'Orsay, Paris

The Temptation of St Anthony

CÉZANNE COMPLETED three paintings on the theme of the temptation of St Anthony. This version is Cézanne's last known working of a subject that had often been represented since the time of Hieronymous Bosch and also described by many nineteenth-century writers. During a period when most of Cézanne's works dealt with erotic subjects and murders, this conventional scene appears to be a representation of the mastering of the sexual conflicts that beset the painter at this time. The temptress, who is placed in the centre of the picture, unveils herself with a triumphant gesture, but she is standing some distance from the hermit, unlike another version of the scene, in which she assails him relentlessly. The devil, who appears on the left, seems to be playing a dual role: he is inciting the temptress as well as, paradoxically, appearing to be the protector to whom the saint clings. A circle of cherubs gives the work the lightness of spirit of an eighteenth-century *scène galante.* In this painting, the woman, an object of

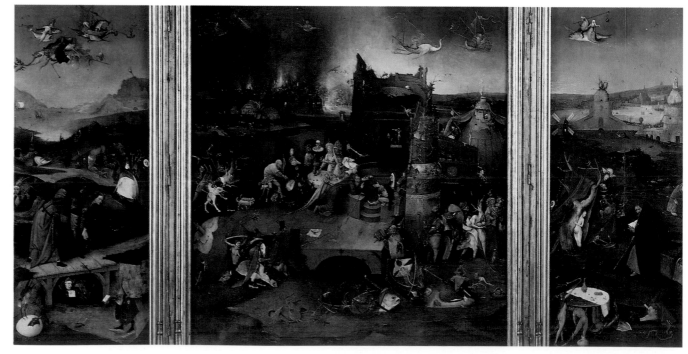

Hieronymous Bosch, *The Temptation of St Anthony*, 1498 Oil on wood (triptych), 131 x 119cm Museu National, Lisbon

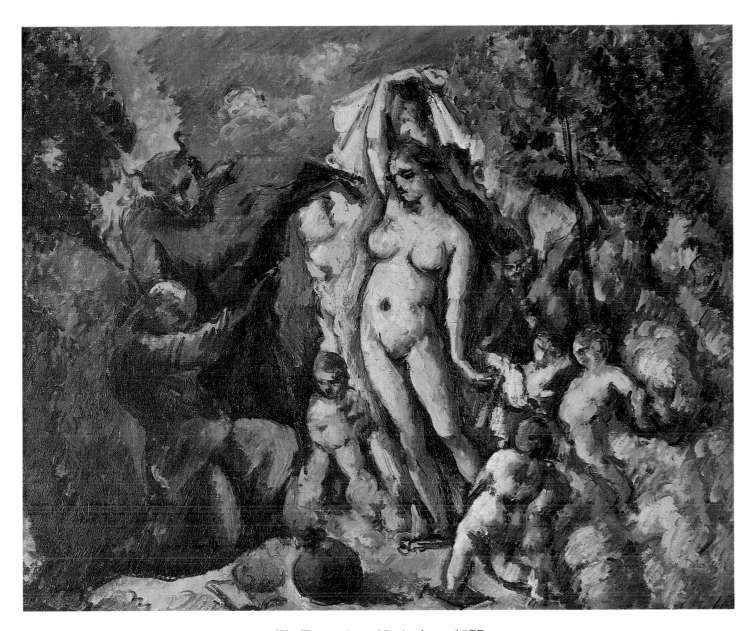

The Temptation of St Anthony, 1877
Oil on canvas, 47 x 119cm
musée d'Orsay, Paris (Gift of M. and Mme Jean-Victor Pellerin)

both adoration and fear, does not seem to be the absolute corrupter of the earlier versions. She has something of a classical goddess about her as well as prefiguring a bather. The heavy shapes of her swaying body are placed in full light, and the white drapery that surrounds her, like a *mandorla* or like the shell of the Venus Anadyomene, forms a strong contrast with, or even a total separation from, the group formed by the entwined devil and saint. At the time he painted this work, Cézanne had just met Hortense Fiquet, and she may have been the model for this buxom nude. Apart from the unhappy liaison that led to his marriage in 1886 and a short sentimental affair in 1885, we do not know if Cézanne had any romantic relationships. In his youth he had idealized romantic, pure love, but by 1885 he had become disillusioned, as he revealed in a letter to Zola in August 1885: 'The brothel in town, or somewhere else, but nothing else. I pay for it. The word is dirty, but I need peace and that is the price I must pay.'

The Battle of Love

AFTER TEN YEARS of producing works inspired by erotic or violent themes, Cézanne brought the series to an end with this scene of a lovers' fight. He made many preparatory sketches for the work, as well as a watercolour and a gouache sketch, and he also made another, more elaborate version in oils. At the same time he began work on a series of bathers, and it is not coincidental that this fanciful composition is set by a stretch of water.

The figures appear as fallen angels, brought together in a violent sexual struggle, in which there is no room for amusement. On the left, a sleeping woman is about to be attacked by a figure in a red cloak that is reminiscent of the one worn by the devil in *The Temptation of St Anthony* (see page 57). The sexual ambiguity of the figures, which is also to be found in the bathers, is especially obvious in the central pair:

a man with strong, muscular legs and long blond hair is about to lay on the ground a woman whose hair is identical to his own. Cézanne expressed the violence of the fight by swiftly rendered hatched strokes, which make the painting look unfinished. Indeed, this could be the first sketch from which the artist produced another painting, kept today in a private collection.

Nature is made to respond to the wild struggle in the movement of the clouds, which obscure the sky. The trees sway, as if blown by a strong wind. The violence of sexual desire is about to reach its climax, and it affects everything around. The dog bounding beside the couple seems to be possessed of the same frenzy, while in many other outdoor luncheon or bathing scenes he is depicted as the faithful, peaceful companion of mankind.

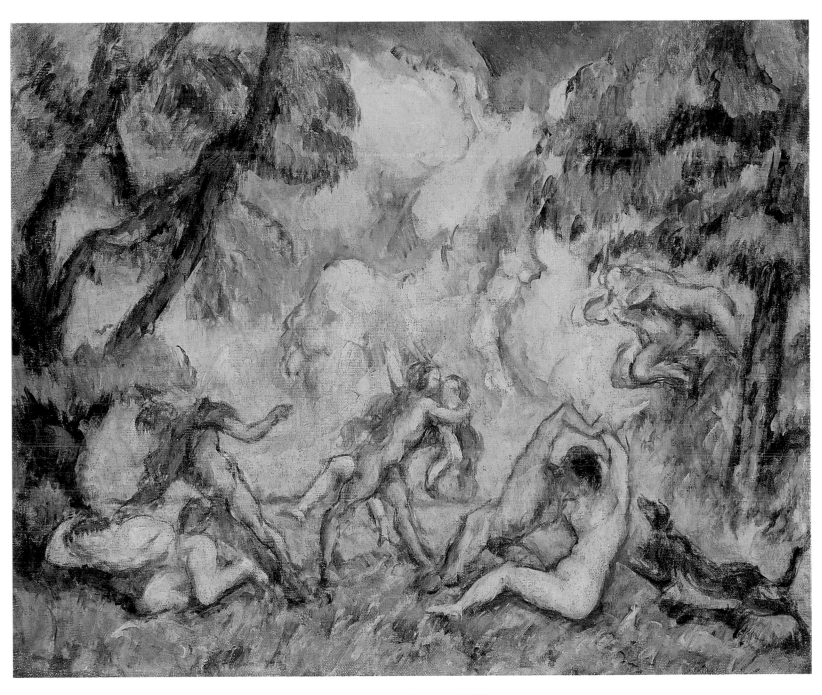

*The Battle of Love, c.*1880
Oil on canvas, 37 x 46cm
National Gallery of Art, Washington D.C.
(Gift of the W. Averell Harriman Foundation in memory of Marie N. Harriman)

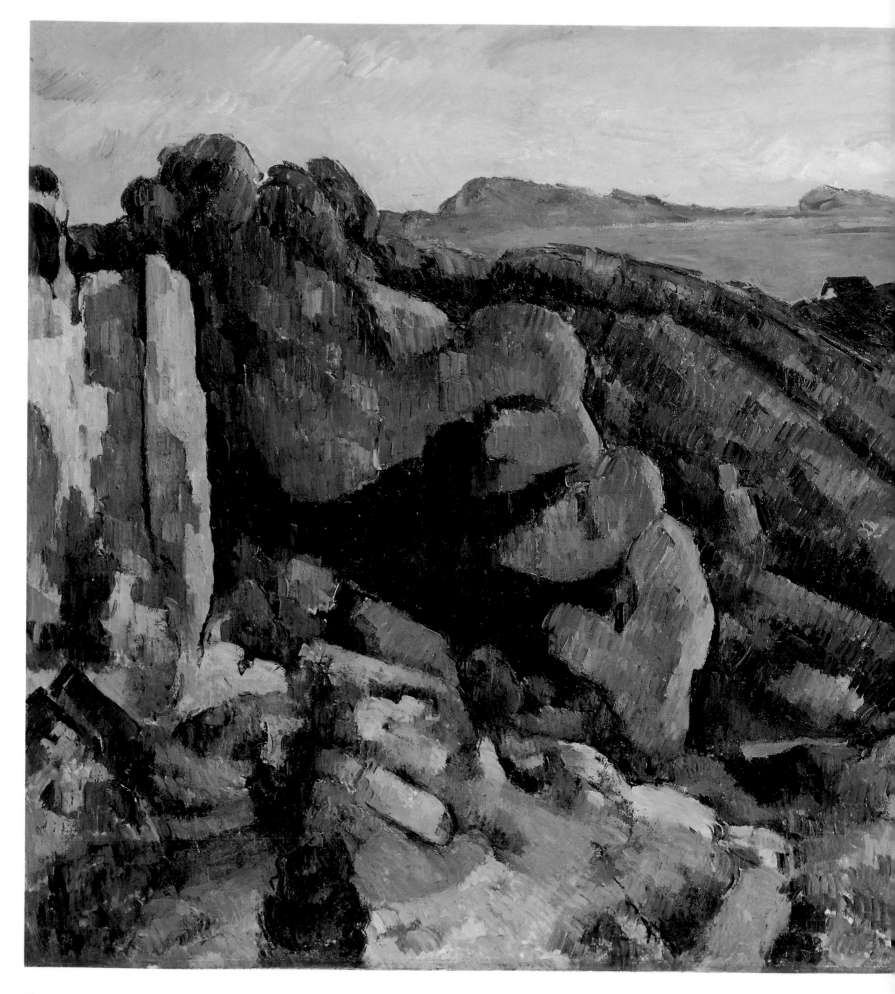

Rocks at L'Estaque, 1880–1882
Oil on canvas, 73 x 91cm
Museu de Arte, São Paulo

L'Estaque

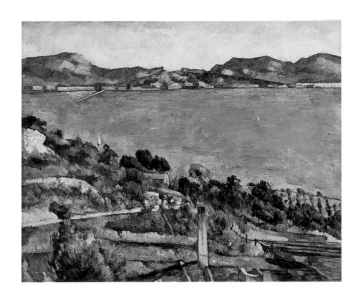

The Bay of Marseilles, Seen from L'Estaque,
*c.*1878–1879, Oil on canvas, 59 x 73cm
musée d'Orsay, Paris
(Gustave Caillebotte Bequest)

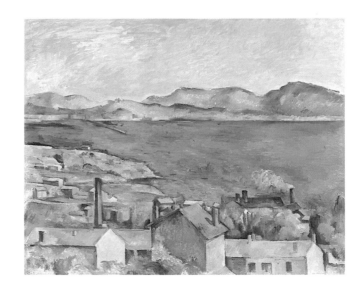

The Bay of Marseilles, Seen from L'Estaque,
1886–1890, Oil on canvas, 80 x 101cm
Art Institute, Chicago
(Mr and Mrs Martin A. Ryerson Collection)

EVEN BY THE END of the nineteenth century L'Estaque was a busy little market town, with around twenty brick and tile manufacturers. Then, it was about ten kilometres from Marseilles, although now it is part of the industrial suburbs of the city. L'Estaque is only about thirty kilometres from Aix-en-Provence, and Cézanne's first recorded visit to the town took place in 1864. It is probable, as John Rewald suggests, that for several years before then Cézanne's mother had been renting a fisherman's cottage there during the summer months. The blue waters of the Mediterranean held a strong attraction for the young Paul, and later, in *Mes Confidences*, he said that swimming was his favourite means of relaxation.

L'Estaque became the refuge to which he escaped from family conflicts. He went there with Hortense Fiquet during the Franco-Prussian War (1870–1871), and it was there that he painted his first outdoor studies: a vertiginous snowscape and a bay in evening light. In 1876 he painted several coastal views for the collector Victor Chocquet, including 'red roofs against the blue sea.' He was enchanted by the place, with the rocks overhanging the bay, the vivid blue of the Bay of Marseilles and the always green vegetation. 'Some subjects demand three or four months' work, but it is possible to take the time because the vegetation does not change. I am talking about the olive trees and pines, which are evergreen,' he told Pissarro in 1876. In 1883 he rented a small house with a garden near the railway station in the Château-Bovis district. In 1883 he wrote to Zola: 'There are some beautiful views. ... If you go up to the top of the hills at sunset you will have a fine panoramic view of Marseilles and the islands, bathed in the wonderful evening light.' He worked on this view of the Bay of Marseilles until the end of the 1880s, with the town of L'Estaque and its chimneys in the foreground, surrounded by the mountains and the great circle of the horizon, where the sea meets the sky. This imposing landscape also inspired Zola, who knew the place well. In his novel *Naïs Micoulin* Zola wrote: 'The countryside is superb. Rocks embrace the bay on both sides, while the islands in the distance stand out against the horizon. The sea is nothing but a vast pool, a lake of intense blue when the weather is fine. ... Beginning at Marseilles, the coastline curls round and digs out inlets before reaching L'Estaque, edged with its factories, which, from time to time, send out plumes of smoke. When the sun is at its highest the sea looks almost black and seems to be asleep between two headlands of rock, all white with warm touches of yellow and brown. Pine trees appear like green stains on the red earth. It is a vast picture, like a glimpse of a corner of the

L'Estaque
Photograph

Rocks at L'Estaque, 1886
Pencil, 22 x 28cm
Private collection

Far East appearing against the jarring glare of daylight.'

The Bay of Marseilles, Seen from L'Estaque (*c.*1878–1879) was the first of Cézanne's paintings to be included in a French national collection, when it was part of the Caillebotte Bequest in 1894.

In 1881–1885 a factory was established in the Rio Valley to exploit the minerals of the Rio-Tinto, and this seems to coincide with Cézanne's departure. He was disgusted by the disfiguring industrial development. Unlike the Impressionists, who were interested in modernity, he included factory chimneys in his paintings only to indicate their presence in the landscape rather than from a wish to illustrate the poetry of modern life. He disapproved of the savage intrusions into a familiar scene, and in 1902 he wrote to his niece: 'I remember perfectly L'Establon and the once picturesque shore at L'Estaque. Unfortunately, this so-called progress is nothing more than an invasion by two-legged animals who are not happy until they have transformed everything into hideous quays with gas burners or – even worse – with electric lights. What times we are living in!'

What to Cézanne was so distasteful, however, found favour in the eyes of the following generation of artists, and at the beginning of the twentieth century Fauvists and Cubists such as Derain, Dufy and Braque set up their easels on the shores of L'Estaque.

L'Estaque and the Bay of Marseilles, 1886
Pencil, 22 x 28cm. Private collection

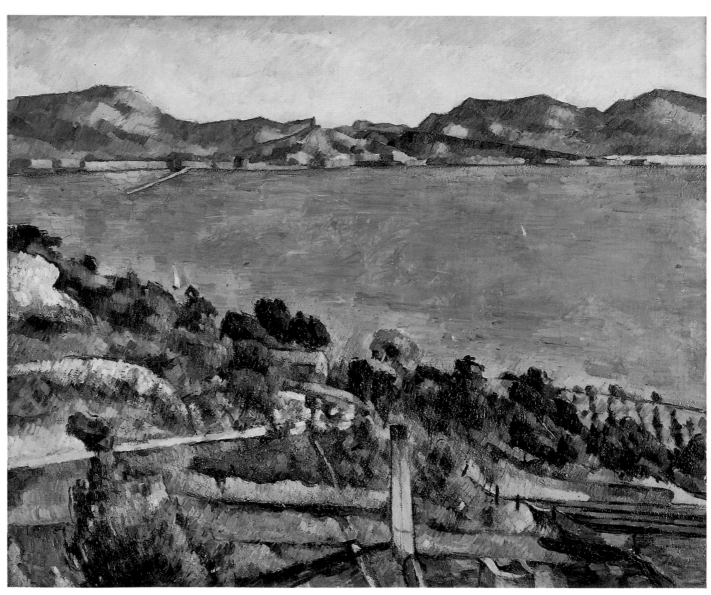

The Bay of Marseilles, Seen from L'Estaque, c.1878–1879
Oil on canvas, 59 x 73cm
musée d'Orsay, Paris (Gustave Caillebotte Bequest)

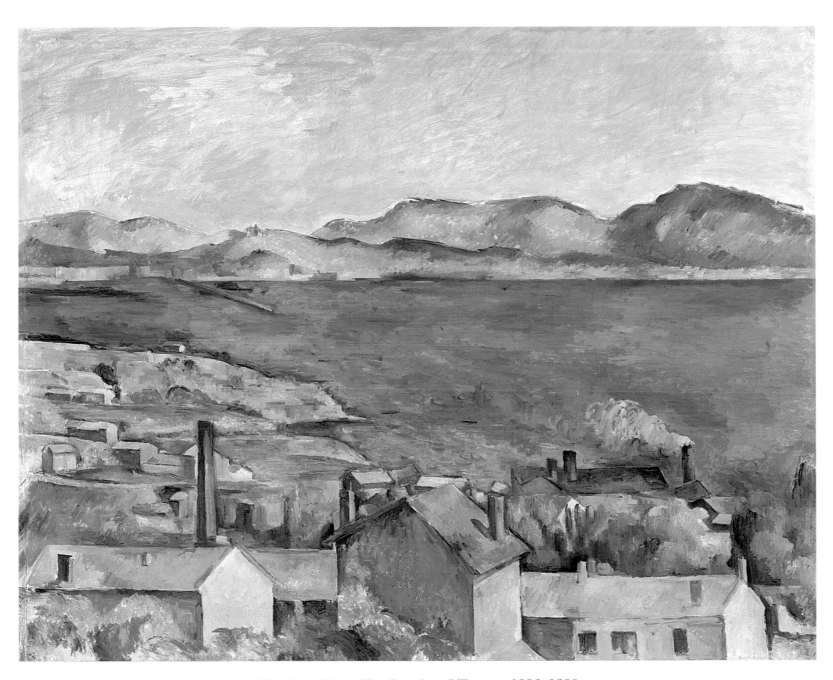

The Bay of Marseilles, Seen from L'Estaque, 1886–1890
Oil on canvas, 80 x 101cm
Art Institute, Chicago (Mr and Mrs Martin A. Ryerson Collection)

The Bridge at Maincy

Between April 1879 and March 1880 Cézanne lived in Melun, where, inspired by the poplars and rivers, he worked on the hills at Mée. The combination of trees and water is a recurring theme in his work. Although he painted the large stretch of water of the Bay of Marseilles at L'Estaque, he also liked the running water of streams and rivers and the smooth surface of lakes.

No human is present in this landscape, which was painted on the banks of the River Almont in the little village of Maincy, to the east of Melun, towards the end of spring or at the beginning of summer in 1879. The composition avoids all anecdotal or sentimental details, and so differs from Corot's landscapes, which show peasant women or washerwomen by the water's edge. Cézanne's landscape does not pretend to be anything other than what it is: a tangle of geometric shapes formed by the tree trunks and branches and by the bridge, which stands out from the colourful but formless background of the foliage and water. A wooden footbridge linking two stone arches runs across the centre of the composition. The painting is entirely built up of slanting squarish or oblong brush strokes, which hold the painting together and give an impression of strength and solidity. Cézanne began to experiment with this mosaic-like method of working at Melun, and it marks the beginning of a new style of painting that went against the Impressionists' practice of breaking up forms in space. Although the subject is simplified, the colour is very complex. The paint is applied in superimposed brush strokes that reveal the ochre underpainting to simulate the fall of light through the trees. Above an old building, which is probably a mill, a little piece of sky is visible in the top left corner, the only opening in this otherwise dense and opaque landscape.

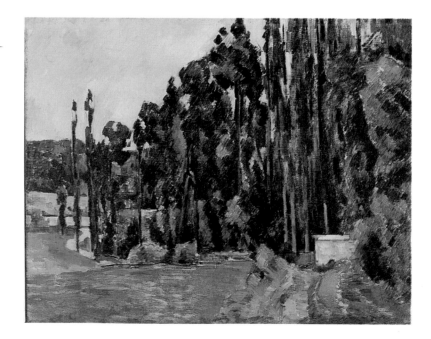

The Poplars, c.1879–1880
Oil on canvas, 65 x 81cm
musée d'Orsay, Paris

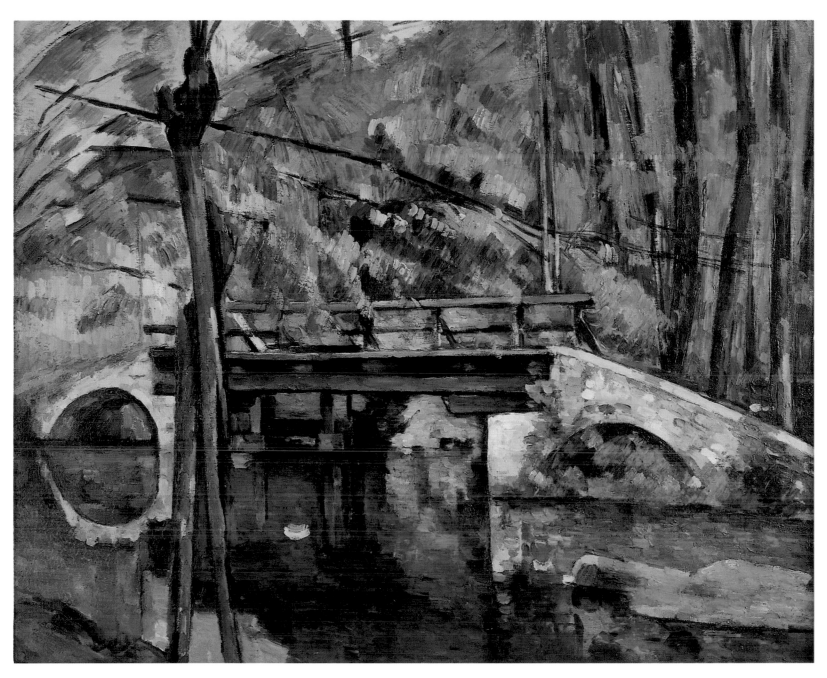

The Bridge at Maincy, 1879–1880
Oil on canvas, 58 x 72cm
musée d'Orsay, Paris

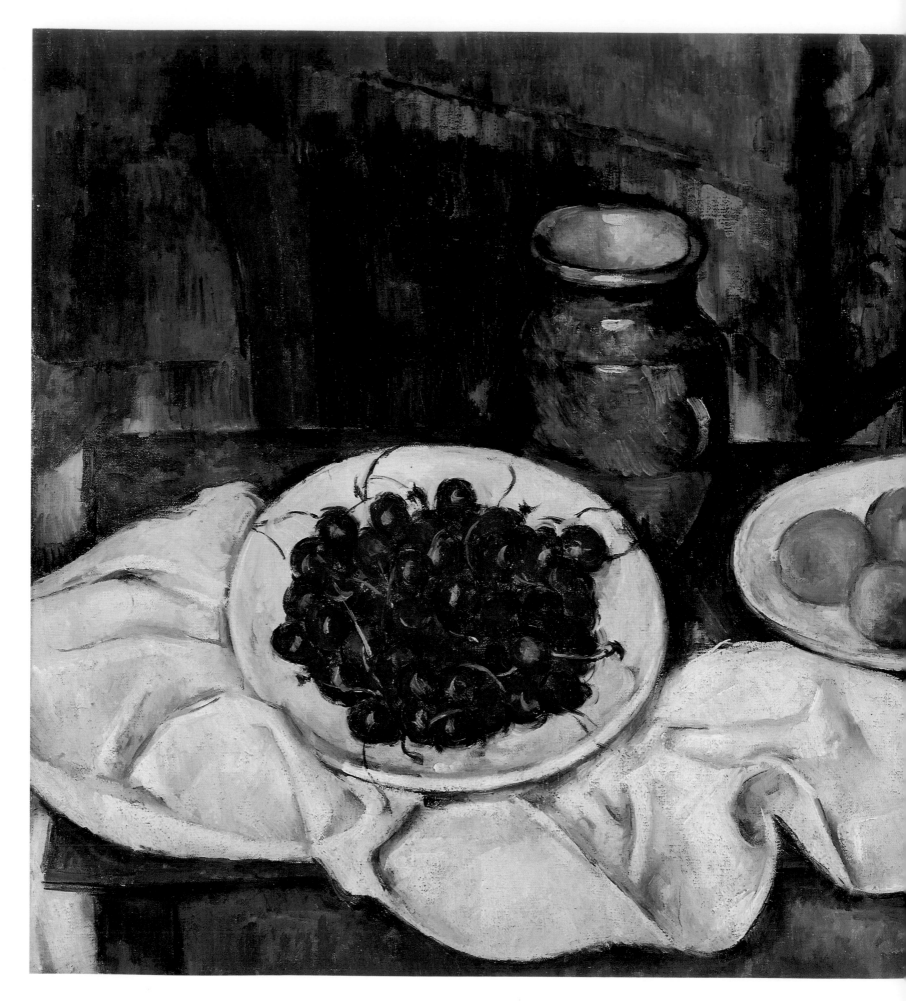

Still Life with Cherries and Peaches,
1883–1887
Oil on canvas, 50 x 61cm
County Museum of Art, Los Angeles
(Gift of the R. Levy Foundation and
of Mr and Mrs S. Deutsch)

Still Lifes 1881–1901

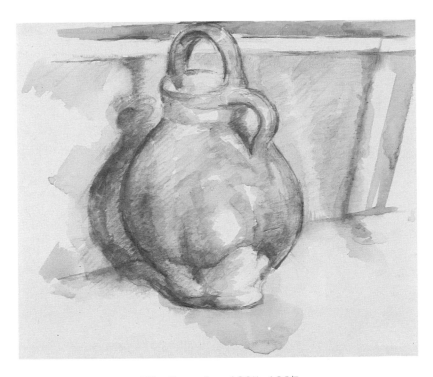

The Green Jug, 1885–1887
Pencil and watercolour, 22 x 24cm
musée du Louvre, Paris
(Département des Arts Graphiques, Fonds Orsay)

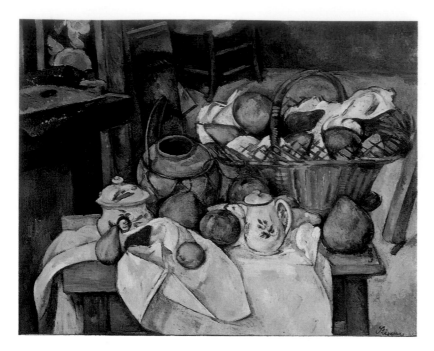

Still Life with Ginger Pot, 1888–1890
Oil on canvas, 65 x 81cm
musée d'Orsay, Paris
(Gift of M. and Mme Jean-Victor Pellerin)

Still Life with Cherries and Peaches, 1883–1887
Oil on canvas, 50 x 61cm
County Museum of Art, Los Angeles (Gift of the R. Levy
Foundation and of Mr and Mrs S. Deutsch)

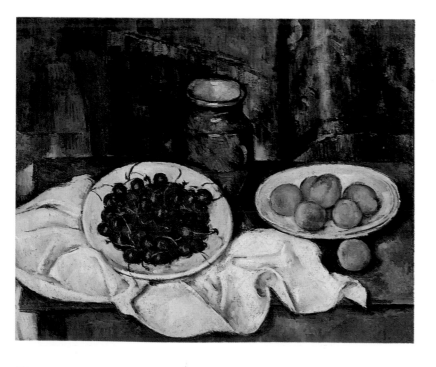

CÉZANNE PAINTED STILL LIFES throughout his life. Despite the apparently innocuous subject matter and the ease with which models could be found, he never regarded a still life as relaxing work. The still lifes have an important place in his work, reflecting the various stages of his search for a personal style. His first still lifes were in the tradition of such masters as Chardin, Courbet and Manet, who owed a debt to the tenebrist tradition of Spanish painting. These were followed, after 1870, by some ambitious works in which he sought to bring his personal themes into focus: simple still lifes arranged in a corner of his studio or in a middle-class home. The essentially static representation of objects in the early works underwent a dramatic change as Cézanne began to represent objects in space. From 1890 Cézanne produced compositions with large numbers of objects, all carefully balanced to create dynamic groups that defy all sense of reality or even probability. Of these works, *Still Life with Apples and Oranges*, which was painted about 1899, is a masterpiece.

His still lifes have a landscape-like grandeur of scale, in which subject, shape and colour combine and interact to form an iridescent whole, created from thousands of tones. Unlike the Impressionists, Cézanne did not abandon the practice of outlining his subjects to emphasize individual forms that were essential to

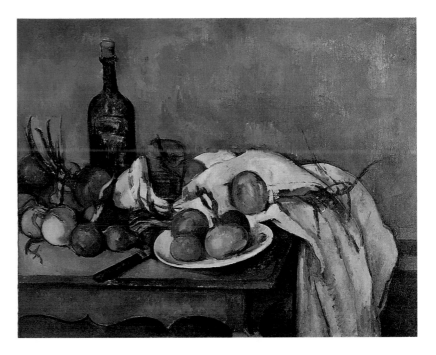

Still Life with Onions and a Bottle, 1896–1898
Oil on canvas, 66 x 81cm
musée d'Orsay, Paris
(Gift of M. and Mme Jean-Victor Pellerin)

the balance of the composition. Nevertheless, he left the outlines broken in order to lead the eye through the painting. The objects are no longer isolated: it is as if they are engaged in a warm, lively dialogue, which reflects the care and attention Cézanne has lavished on them. He explained this to Joachim Gasquet: 'Those glasses and plates are talking to each other, endlessly exchanging secrets.'

Cézanne insisted that this exchange was vital and that there must be a palpable attraction between inanimate objects, which is normally denied to them. He lent them his own sensibility when he said: 'Objects penetrate each other. ... They do not stop living. ... They spread imperceptibly around each other, through intimate reflections, as we do through glances and words.' He chose simple, everyday objects for his still lifes, and they reappear in picture after picture: the white ceramic fruit dish, the squat round sugar bowl, the Marseilles pottery, the ginger jar with its wicker holder, the bottle of rum surrounded by straw and the jug with the floral pattern. For backgrounds he used three different fabrics, sometimes singly, sometimes together: one blue with a deep ultramarine floral pattern, another with a pattern of blue and ochre leaves, and a third fabric, a thick woollen cloth or rug, with a brown, red and green check. This preference for simple subjects is seen again in his selection of fruits, which he chose as

*Still Life with Apples and Oranges, c.*1899
Oil on canvas, 74 x 93cm
musée d'Orsay, Paris
(Isaac de Camondo Bequest)

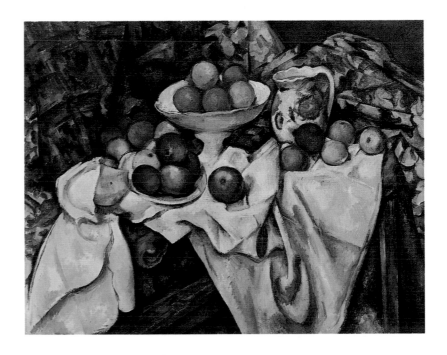

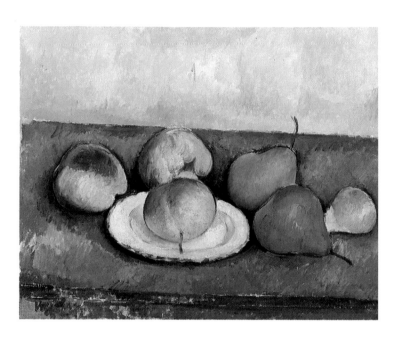

Still Life with Apples and Pears, c.1883–1887
Oil on canvas, 38 x 46cm
Private collection

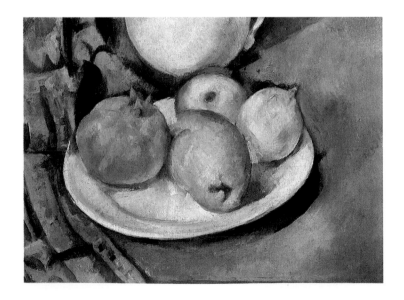

much for their solidity as for their shape and colour. He preferred robust fruits such as apples, oranges, pears and lemons, to the more fragile fruits of Provence such as grapes, figs and apricots – the cherries in *Still Life with Cherries and Peaches* are an exception. He also introduced aubergines and onions into his compositions because of their shiny, silky skins and deep colours.

Cézanne needed a considerable number of sessions to complete his paintings and this is probably why there are fewer still lifes with flowers than compositions with fruit. Joachim Gasquet records him as having said: 'Fruit are faithful... They like having their portraits painted. They sit there as if they were asking forgiveness for changing colour. They exhale their spirit together with their fragrance. They approach you through their scents and talk to you about the fields they have left, the rain that has fed them, the dawns that they have seen. When I use juicy paint to outline the skin of a beautiful peach or the melancholy of an old apple, I catch a glimpse, in the reflections they exchange, of the same faint shadow of

Still Life, c.1893–1894
Oil on canvas, 26 x 35cm
Stephen Hahn Collection, New York

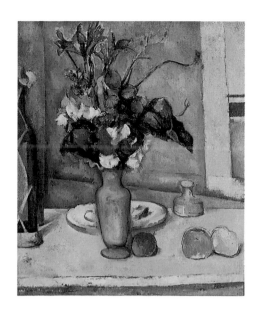

The Blue Vase, 1883–1887
Oil on canvas, 61 x 50cm
musée d'Orsay, Paris
(Isaac de Camondo Bequest)

renunciation, the same love for the sun, the same memories of dew, of freshness.'

Renoir recounted that Cézanne used paper flowers for his paintings. Cézanne began to paint bunches of flowers about 1870, when he made contact with the Impressionists. His first compositions with flowers are of single vases, but in the following decade he mixes flowers with fruit, and later still they become the only subject matter, filling the whole canvas. Although he did not collect the works of his contemporaries, towards the end of his life Cézanne bought from Vollard a superb watercolour by Delacroix of a bouquet of flowers, of which he painted a copy. The exuberance of these flowers is at one with the baroque style of his last works. Even more than his landscapes or scenes with bathers, Cézanne's later still lifes with flowers and fruits

The Blue Vase, detail

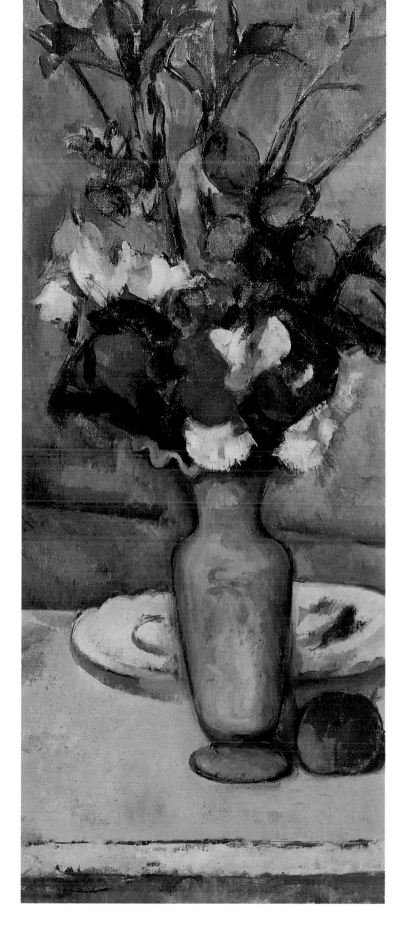

celebrate a joy achieved through the successful balancing of sensual, spiritual and intellectual qualities. Unlike most of his work, which was for so long decried, these compositions enjoyed early success. Huysmans, who did not like Cézanne, made an exception with these still lifes. In 1907, when the first retrospective exhibition was organized by the Salon d'Automne, one critic ventured to praise them: 'His craftsmanship shows itself mainly in his still lifes, and the sight of them awakens in us a feeling that we can actually touch them – the fruits on a plate, the beautiful bright red, green and yellow apples, the sour grapes, the pink onions, a plate, a porcelain fruit bowl, a salt-glazed pot, a black marble clock – these things are real and continue to exist.' Paradoxically, the strength of these works derives from their complete lack of artifice and from Cézanne's depiction of the fundamental meaning of the objects, fruit and flowers. He once said: 'I want to astonish Paris with an apple.' He invested in these works, especially in the fruit, all his virtuosity and all his love, finding in them a universal significance.

Still Life: Utensils and Fruit (The Kitchen Table), 1900–1904
Pencil and watercolour, 28 x 47cm
musée du Louvre, Paris
(Département des Arts Graphiques, Fonds Orsay)

Still Life on a Table, 1902–1906
Pencil and watercolour, 47 x 52cm
Collection of Mr and Mrs E.V. Thaw, New York

Kitchen Table: Pots and Bottles, 1902–1906
Pencil and watercolour, 21 x 27cm, musée du Louvre, Paris
(Département des Arts Graphiques, Fonds Orsay)

Still Life with Pomegranates, Sugar Bowl, Bottle and Watermelon, 1902–1906
Pencil and watercolour, 30 x 40cm musée du Louvre, Paris (Département des Arts Graphiques, Fonds Orsay)

75

Still Life with Fruit Stand, Glass and apples

Maurice Denis, *Homage to Cézanne*, 1900
Oil on canvas, 180 x 240m
musée d'Orsay, Paris (Gift of André Gide)

GAUGUIN WAS THE first owner of this superb still life, and it is featured in the background of a portrait of a Breton woman (now in the Art Institute, Chicago). Although he had financial problems, Gauguin put off parting with it for a long time, for he regarded it as a masterpiece. It was, he wrote in June 1888: 'An exceptional pearl, and I have refused 300 francs for it. I regard it as the apple of my eye, and unless I am absolutely desperate I will part with it only after my last shirt. In any case, what lunatic could afford it?' According to the Polish painter Maszkonoski, Gauguin used the painting to illustrate to a small group of painters who used to go to La Crémerie de Mme Charlotte what he considered to be the essence of Cézanne's work. Another tribute was paid to Cézanne ten years later by Maurice Denis when he included this work in the centre of his large composition *Homage to Cézanne*. Cézanne's painting, which has achieved the status of an icon, perfectly illustrates both the subject matter of the artist's still lifes, with its apples, white porcelain fruit stand, white folded napkin and the knife, placed diagonally to indicate depth, and his technique of using systematically applied overlapping patches of colour to build up the painting. Chardin's influence is apparent in the well-balanced composition, in which fresh, bold colours, sensuous, round shapes and heavy and light paint blend as harmoniously as in music. As Fülep remarked in 1906: 'Cézanne belongs with those legendary individuals who delight the crowds with seven apples and a few breaths of air.'

Still Life with Fruit Stand, Glass and Apples, 1879–1882
Oil on canvas, 46 x 55cm
Private collection

Madame Cézanne in a Red Armchair

CÉZANNE MET ÉMILIE HORTENSE FIQUET early in 1869, and she became his companion. They were married in 1886, six months before the death of Cézanne's father.

Hortense was born on 22 April 1850 at Saligney in the Jura, and she was eleven years younger than the artist. In 1872 she gave birth to their son, who was also named Paul. Although his mother knew about the relationship, Cézanne concealed it from his father, who only later accidentally learned of the liaison and his grandson. Even then, Hortense was not accepted, either by the painter's family or by his circle of friends.

The Zolas, who led a respectable, middle-class life, avoided her and called her *la boule* ('the ball'), possibly because of her rather round face. The nickname was taken over by even more malicious people, who called the couple's son *le boulet* (literally a canon ball, figuratively a millstone around the neck), which says much about the relationship.

Cézanne and Hortense did not live under the same roof for very long. Hortense preferred to live in a large town – Paris or Marseilles – while Cézanne was working at Aix or L'Estaque.

Little is known about Hortense before she met the painter. Her liking for

Madame Cézanne, c.1886
Oil on canvas, 47 x 39cm
musée d'Orsay, Paris
(This painting belonged to Henri Matisse)

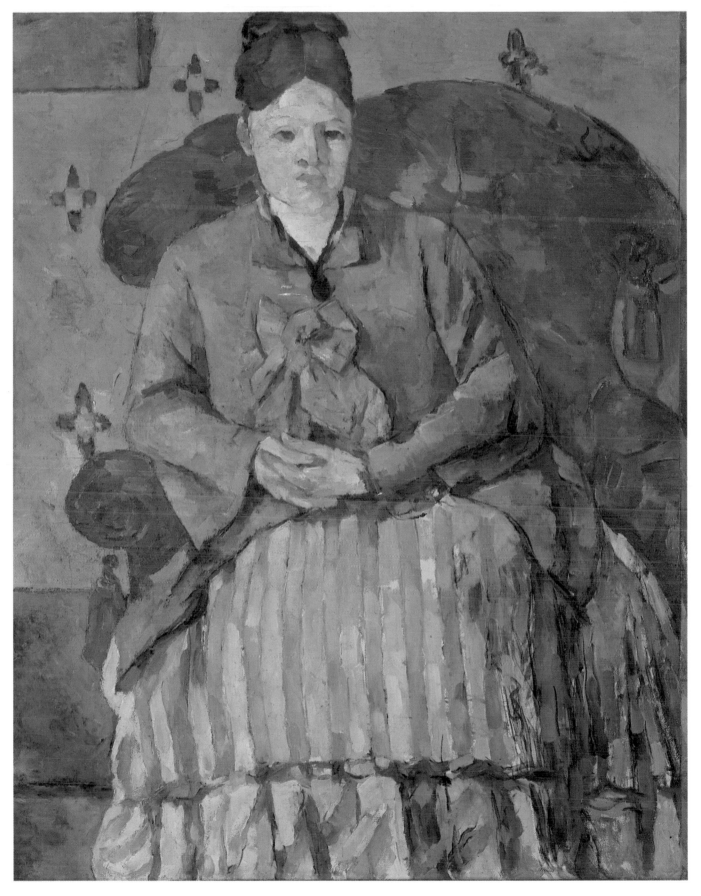

*Madame Cézanne in a Red Armchair, c.*1877
Oil on canvas, 72 x 56cm
Museum of Fine Arts, Boston, Massachusetts (Robert Treat Paine II Bequest)

fine clothes suggests that she might have been a model or a dress-maker, and it is said that she chose to keep an appointment with her seam-stress in Paris rather than catch the next train to Aix to be with her dying husband. Although she does not seem to have been over-endowed with good qualities, her in-laws did acknowledge that she was even-tempered and possessed unlimited patience. These characteristics explain how she could bear the endless sittings that Cézanne demanded of her without quailing.

In the painting *Madame Cézanne in a Red Armchair* she is shown wearing an outfit of moiré satin, with a plain jacket fastened by a large bow. The full skirt occupies almost half the painting. She is sitting, leaning slightly to the left, in a red armchair decorated with tassels. Her hair is fastened on the top of her head, which is unusual, because in most portraits she is shown with her hair parted in the centre and drawn back from her face in a way that emphasizes its roundness.

Hortense posed for her husband on many occasions. Sitting in a chair, with her hands together and her hair drawn back into a bun, she was resigned to the sessions. Her passivity and patience suited the artist, who required more than a hundred sittings for a portrait. These numerous sittings may explain the vacant look and pursed lips, but they also probably reveal Cézanne's intention of looking beyond the outward appearance and immediate impression in order to portray the timelessness of his model and to paint figures in the same way that he approached still lifes and landscapes.

Madame Cézanne in a Red Dress, 1890–1894
Oil on canvas, 116 x 89cm
Metropolitan Museum of Art, New York
(Mr and Mrs Henry Ittleson Jr Purchase Fund)

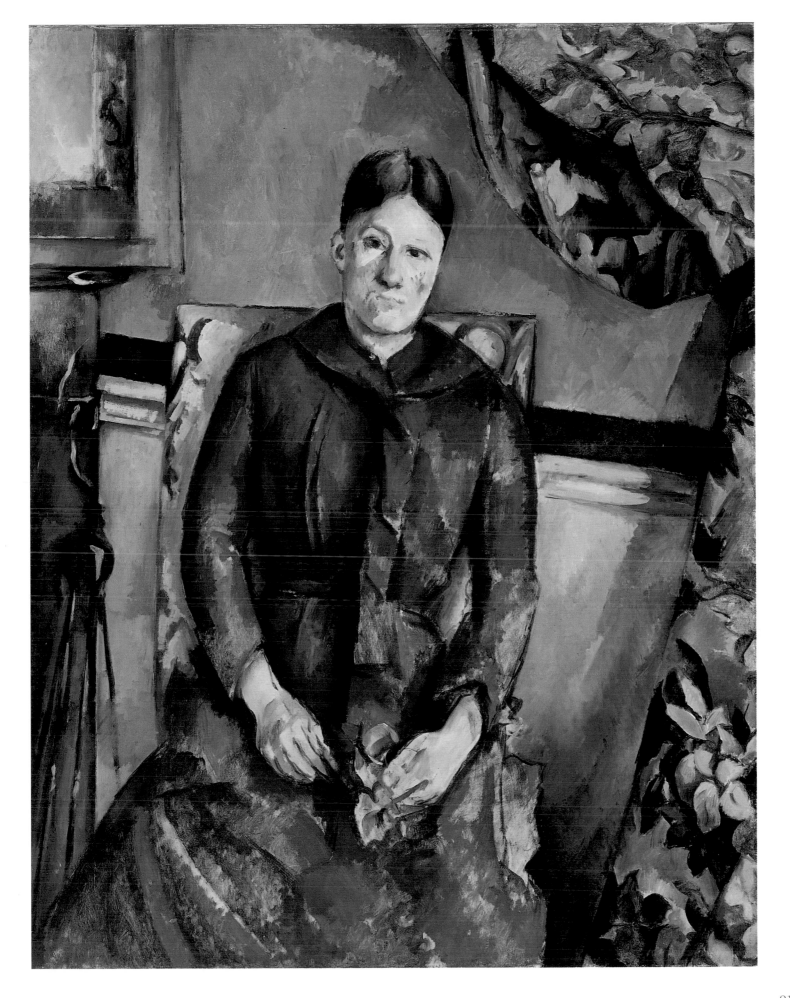

Portrait of Paul Cézanne, the Artist's son

THIS PAINTING IS PROBABLY the first finished portrait of Cézanne's son, Paul. At the time of the portrait he would have been twelve or thirteen years old; before then he would have been too young to have held the pose. There are, however, numerous drawings of the boy, made by the doting father, in which Paul is seen sleeping or gazing out of the drawing with his large, dark eyes. His childish writing appears in the corner of his father's sketchbook to identify his portrait – 'Paul' – or that of his mother – 'Madame Cézanne.'

Paul was born on 4 January 1872 at 45 rue de Jussieu, in a popular area of the Left Bank of Paris, and Cézanne acknowledged him immediately. Nearly thirty years later he wrote to his friend Louis Aurenche to congratulate him on the birth of his son: 'You will soon understand what he is going to mean in your life.' Cézanne's correspondence reveals something of the love and concern he felt for his child.

In the last years of his life, when he no longer trusted anyone, it was on Paul that he depended. Cézanne entrusted him with everything, from negotiating with Vollard or the other dealers to buying paintbrushes or a pair of slippers; from helping him to move house to enter-

taining his friends. He wrote about him to the young painter Charles Camoin. 'My son, who is at present in Paris, is a great philosopher, although I do not mean that he is on a par with Diderot, Voltaire or Rousseau. Would you honour him with a visit to 31 rue Ballu, near Place Clichy, with its statue of General Moncey? When I next write to him I will mention your name. He is rather sensitive and seems unemotional, but he is a good boy. His intervention helps me to overcome the difficulties I have in understanding life.'

On 26 September 1902 Cézanne named Paul as his only heir. This exclusive love can be seen in the artist's voluminous correspondence and in a few painted portraits. It is likely that Paul was a model for the bathers. As a child he posed in a blue school smock in a corner of the red armchair shown in the portrait of his mother on page 79. (This painting is in Museum of Art, Yokohama.) In fact, he bears a strong resemblance to Hortense, with his round face, thin lips and rather underhung jaw. Cézanne chose a tight centring for this small portrait, which brings together in rather a strange juxtaposition the smooth shape of the boy's head and the curve of the back of the armchair.

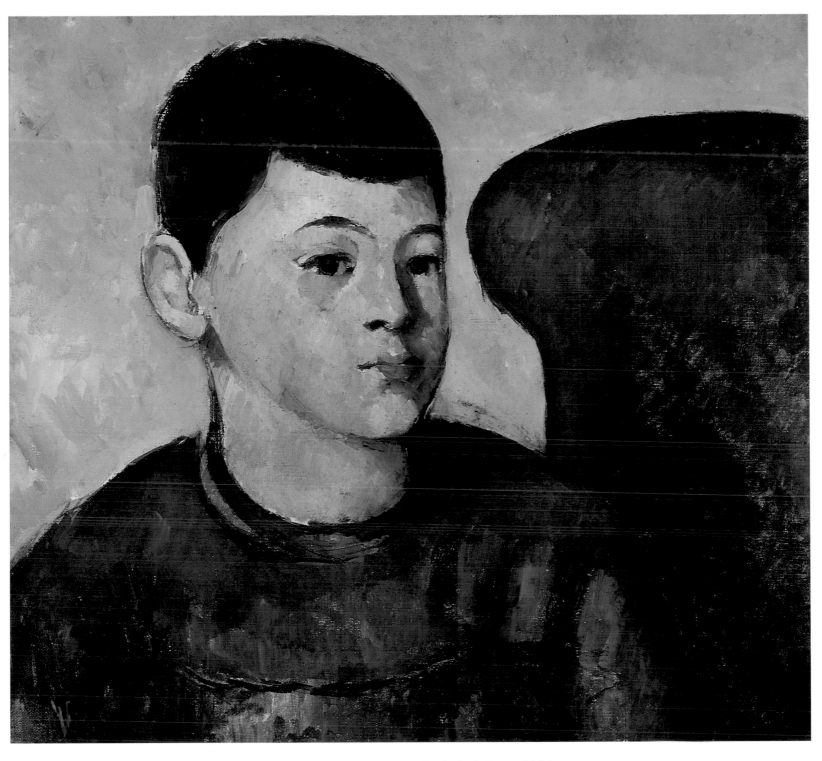

Portrait of Paul Cézanne, the Artist's Son, c.1884
Oil on canvas, 35 x 38cm
musée de l'Orangerie, Paris (Collection of Jean Walter and Paul Guillaume)

Self-Portrait with a Palette

OUT OF TWENTY-FOUR known self-portraits, only one shows Cézanne at work, by his easel and with a palette in his hand. In most of the others he faces the viewer, close to and in full light. It is possible to follow the evolution of his changing facial features and his developing baldness, which he often hid, through vanity, under a hat. Cézanne did not like people to watch him paint, and this may partly explain why he painted this unique self-portrait of himself as an artist, a subject matter that has been popular with painters since the seventeenth century. In addition to his reticence about portraying himself at work – without a tie and wearing an ordinary jacket – the painting may hide the difficulty he experienced in asserting himself as a painter in the eyes of other people, especially his father. Two important events occurred in 1886 – his marriage to Hortense Fiquet and the death of his father less than six months later – and they are, perhaps, reflected in this self-portrait, which, like most of his work, is neither signed nor dated. The painter's impedimenta – the canvas placed on the easel, viewed from the back, the palette and the brush – occupy an important place in the composition. They create a frame – perhaps some form of protection – behind which the artist is seen. This arrangement, as Jean Leymarie was the first to point out, exerted a strong influence on van Gogh, who used it in a self-portrait dating from January and February 1888. In most traditional portraits or interiors the main subject stands out against a background embellished with decorative elements,

Vincent van Gogh, *Self-portrait at the Easel*, 1888, Oil on canvas, 65 x 50cm Van Gogh Museum, Amsterdam

but here the accessories are brought to the foreground, while the background remains empty. The geometric shapes of the canvas and palette seem to communicate a certain stiffness to the artist's chest and shoulders. His face has a distant look, the impassive features reflecting the concentration of the artist at work. Cézanne gives us an image of himself scrutinizing the face that he is simultaneously transferring to the canvas. The mystery of the individual and of the painting are being fused in this reciprocal gaze. This self-portrait reveals the intense relationship between the artist and his work.

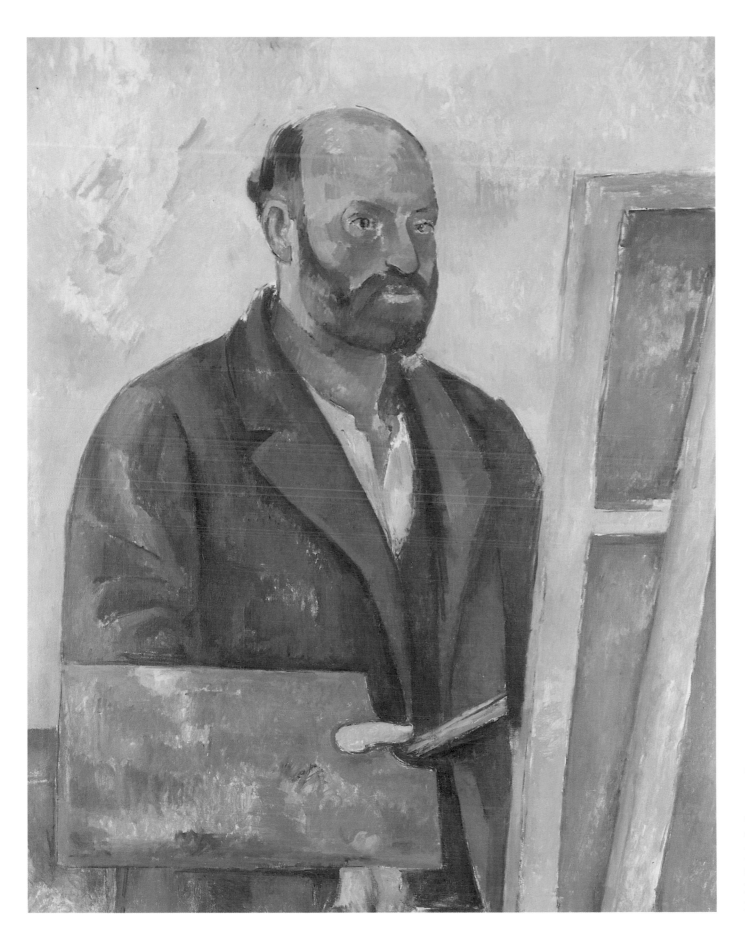

*Self-portrait
with a Palette,
c.*1886
Oil on canvas,
92 x 73cm
Foundation
Collection of
E.G. Bührle,
Zurich

Mardi Gras
(Pierrot and Harlequin)

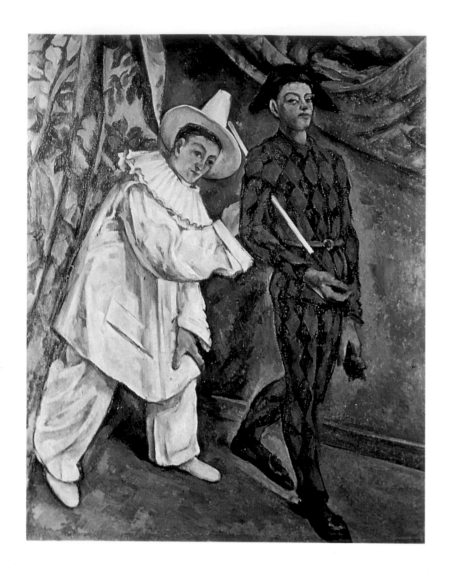

I N HIS YOUTH, Cézanne, like Zola, loved the carnival, which led to all kinds of festivities in his home town of Aix-en-Provence. The youngsters would enthusiastically take part in all the masquerades, pageants and processions. Perhaps it was in remembrance of those happy days that Cézanne asked his son to pose for him dressed as Harlequin and proudly leading an imaginary procession, while Louis Guillaume, in Pierrot's costume, follows in his footsteps and looks as if he is about to steal Harlequin's baton. According to Paul, this scene was painted in Paris in the studio in the rue du Val-de-Grâce, which Cézanne occupied from late 1888. Before beginning this particular work, Cézanne had produced many drawings inspired by the *commedia dell'arte* and three separate paintings of Harlequin.

In contrasting costumes, Pierrot and Harlequin set each other off, making a lively

Above: *Mardi Gras (Pierrot and Harlequin)*, 1888–1889, Oil on canvas, 102 x 81cm
Pushkin Museum, Moscow

Left: *Studies for Mardi Gras, c.*1888
Pencil, 24 x 30cm
musée du Louvre, Paris
(Département des Arts Graphiques, Fonds Orsay)

scene that is exceptional among Cézanne's compositions of several figures, in which the protagonists are usually indifferent to each other and appear almost as if they were alone. Here, the looks and gestures reveal a close relationship between the two young people. The deliberate flouting of the laws of perspective, with the floor coming down steeply, emphasizes the expression of the attitudes and accounts for the distortions. For example, Harlequin's feet have to be lengthened so that he can stand.

The two characters seem to be emerging from the wings of a theatre, and this is suggested by the large drapes of the same leafy material that Cézanne used in his still lifes. The artist worked especially carefully on the fabric and costumes. Pierrot's outfit, baggy and immaculate, reflects all the surrounding colours and, in turn, illuminates the boy's face. Next to him, Harlequin's slim figure, dressed in a red and blue check costume, brings a warm, cheerful note to the painting. A certain degree of humour, uncommon in Cézanne's works, emanates from this carnival scene.

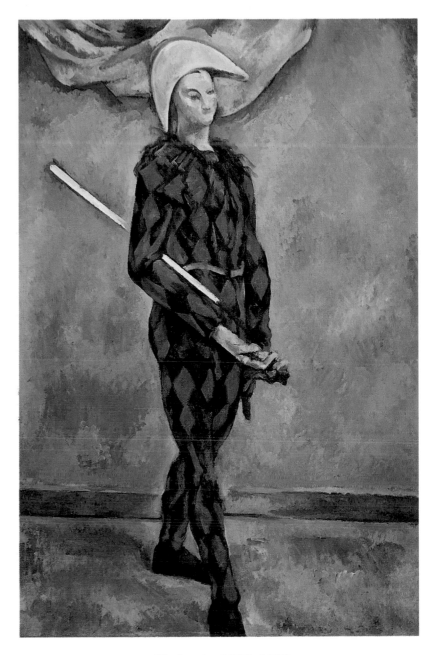

Harlequin, 1888–1890
Oil on canvas, 101 x 66cm
National Gallery of Art, Washington D.C.
(Mr and Mrs Paul Mellon Collection)

Boy in a Red Waistcoat

Cézanne produced two watercolours and four oil paintings (two full face, one profile and one three-quarter face) from the same model, an adolescent of Italian extraction, Michelangelo di Rosa. In all four oil paintings the youth is seen wearing the same famous red waistcoat, which gave its name to the portraits. As well as his well-groomed appearance – that of a peasant boy from the countryside around Rome – the boy's fine-featured and thoughtful face, his long hair and melancholy attitude give the portrait a romantic look, which anticipates the meditative qualities of *Young Man with a Skull* (see page 106). It also prefigures a series of studies of individuals, smokers and peasants, leaning on their elbows, which Cézanne painted about 1895.

At this time, more than any other, Cézanne made numerous studies of the human figure, and he paid particular attention to integrating the human form into its surroundings. This concern is apparent in this painting, in which the subject is propped up between a curtain on the left and, on the right, by either a cushion or a table covered with a rug on which he is leaning. The wall behind the youth is a complex surface that throws the figure into the foreground. Seen from above in full frame, the figure seems to be sliding towards the viewer, but the elongated arm, bent at a sharp angle, restores the balance and brings it back into the picture. The painter Max Liebermann remarked: 'The rendering of this arm is so beautiful that I would like it to be even longer.'

Cézanne was not concerned with anatomical exactitude. He worked by a process of simplification, reducing the shapes to a sequence of flat areas, which find a mutual equilibrium. Unlike traditional portraitists, he did not establish any hierarchy in the treatment of the different parts of the body. The hands and face, unfinished, are deliberately neglected, while the shirt, which is worked in depth, represents a work of art in its own right. Two notes of bright colour – the red of the waistcoat and the blue of thc belt – enhance the vividness of the composition, in which green, light blue and beige are dominant.

Boy in a Red Waistcoat, 1888–1890
Oil on canvas, 80 x 64cm
Foundation Collection of E.G. Bührle, Zurich

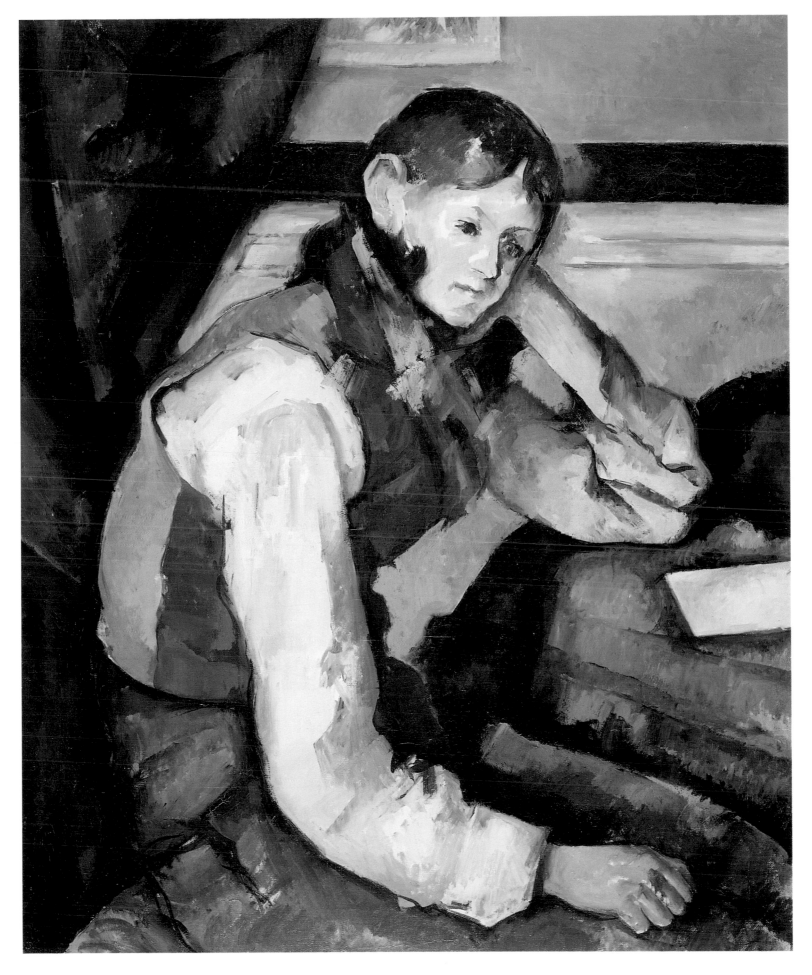

House and Farm at the Jas de Bouffan

On 15 September 1859 Louise-Auguste Cézanne bought a country estate from Gabriel Fernand Joursin. He paid 85,000 francs for the fifteen or so hectares, which were situated about two kilometres from Aix-en-Provence. The name of the estate, the Jas de Bouffan, was a Provençal expression meaning 'shepherd's shelter' (that is, shelter from the wind). The Cézanne family did not live permanently in their country residence, as they kept on an apartment in town, but they got into the habit of spending several months there each summer, and they sought refuge there during the Franco-Prussian War. The painter grew fond of this superb house, which was built in the eighteenth century and had originally been the country residence of the Governor of Provence, M. de Villars. It was there that Cézanne made his debut as a painter, when he decorated the living room with four huge canvases depicting the four seasons in a pastiche of eighteenth-century rococo style and mischievously signing them 'Ingres.' It was also at the Jas de Bouffan that he painted portraits of his uncle Dominique Aubert and of his father.

Between 1881 and 1885 Cézanne's father had a studio built in an attic for his son, and the large house and grounds provided the artist with a vast range of subjects. Until he sold the estate on 18 September 1899, Cézanne produced many paintings, drawings and watercolours depicting the house and grounds, which suggest that he worked there with unalloyed pleasure.

In this painting, now in the National Gallery of Prague, the house, with its windows framed with blue shutters, and the neighbouring farm are treated as a study in geometric forms. The simplified configuration does not, however, give an uninteresting impression. The large building seems to be leaning to the right, and this may be why the painting was left unfinished. The soft light of the Midi falls on the colours, making the ochres and blues shimmer. Only the tiles of the re-roofed house illuminate the composition with a sustained orange-red.

The Pool at the Jas de Bouffan, c.1870
Watercolour and gouache, 11 x 19cm
Private collection

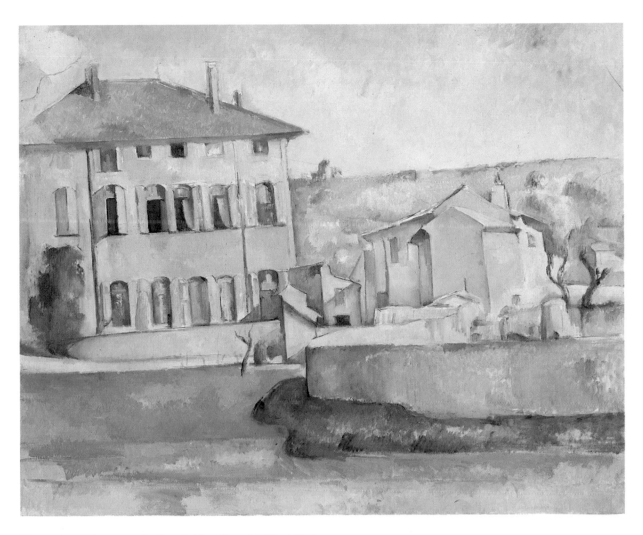

House and Farm at the Jas de Bouffan, 1889–1890
Oil on canvas, 61 x 74cm
National Gallery, Prague

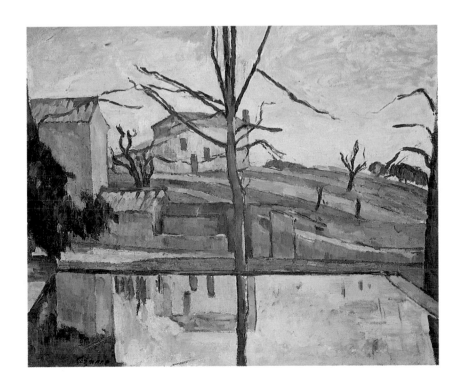

The Pool at the Jas de Bouffan, c.1878
Oil on canvas, 52 x 56cm
Private collection

The Card Players

THERE ARE NO FEWER than five painted versions of this card game, with either two or three players, and with or without spectators, as well as numerous preparatory sketches, watercolours and related pictures. Cézanne worked at length on this subject, which is a classic theme of French painting. He would have been aware of *The Card Players* of the School of Le Nain, which is in the musée Granet in Aix-en-Provence. The theme was popular in the seventeenth century, but while earlier painters had sought to represent moral or anecdotal scenes – the card-sharp, Luck or a lively tavern interior, for example – Cézanne produced a de-dramatized version of the game, which André Breton described as 'half tragedy, half farce.' The two players are facing each other across a simple wooden table, which is covered with a cloth or gaming rug. Dispassionate and silent, they look down at the cards in their large, impassive hands. Cézanne had often had opportunities to observe at leisure such games of cards, which were played in the cafés of the Cours Mirabeau of Aix-en-Provence, where he would go after a day's work. He does not, however, confine himself to a realistic portrayal of a card game. It is as if he has reduced the event to its most basic elements – two players, an anonymous background, no onlookers – and just a few descriptive details – the clay pipe and a bottle of wine. The sombre nature of the setting gives the players a grandeur reminiscent of the figures in Masaccio's paintings.

Two farm workers from the Jas de Bouffan came to sit in the family home for this scene. They wore their Sunday-best clothes and new hats. The brush strokes that, colour patch after colour patch, were used to build up the painting were wrongly interpreted as stains on the clothes and tablecloth by André Pératé, the critic from *La Gazette des Beaux-Arts*, when he came across the work at the retrospective exhibition of the Salon d'Automne in 1907. Certain of the rightness of his opinion, he considered the work to be a true manifesto of realism in the style of Courbet, and he wrote: 'Is it not just like looking through an open window into this shabby café, where whiffs of absinthe hang around and where flies have left their marks on the walls?' Cézanne was, of course, interested in the subject matter – it is never wholly absent from his work – but its anecdotal aspect was unimportant to him. He was not a genre painter, and he chose only those subjects and places for his works that had a timeless quality.

The Card Players, 1890–1892
Oil on canvas, 47 x 57cm
musée d'Orsay, Paris
(Isaac de Camondo Bequest)

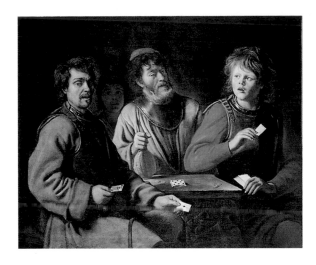

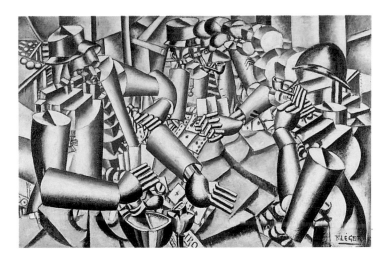

Le Nain School, *The Card Players*, 1635–1640
Oil on canvas, 63 x 76cm
musée Granet, Aix-en-Provence

Fernand Léger, *The Card Players*, 1917
Oil on canvas, 129 x 193cm
Kröller-Müller Museum, Otterlo

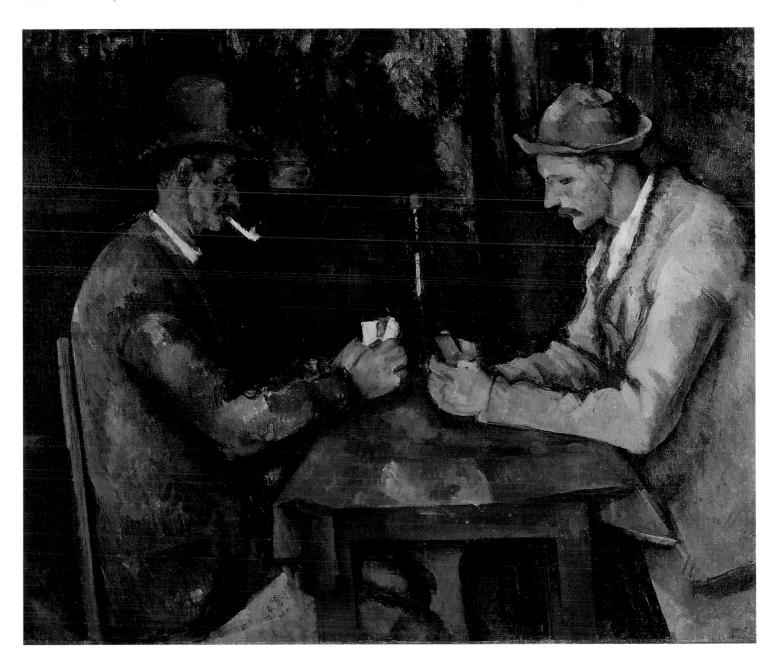

Woman with a Coffee Pot

THERE IS SOMETHING of Masaccio or Picro della Francesca in this large, simple figure of a woman. According to one of her descendants, the model was a servant, who would have posed for the sittings in Paris, not at the Jas de Bouffan. This may be the reason for the stiff, rather uneasy attitude of the sitter. The resemblance in the pose to some of the portraits of Hortense Fiquet, who has sometimes been identified as the woman with the coffee pot, may suggest that Cézanne deliberately wanted to keep an emotional distance from his model. The expression on her face is enigmatic. Lionello Venturi noted, quite accurately, that 'she is standing there as firm as a tower.' The thick, dark hands are accustomed to domestic work, and their simplified shape makes them look like barely trimmed blocks of wood or lumps of inanimate flesh. The model's body is completely hidden under the full but severe blue dress, the geometric folds of which are reminiscent of the sharp reliefs of Mont Sainte-Victoire. This lifelessness is compensated for by the vibrant rendering of the composition and the light, which modifies the colours. Here and there, spots of white light catch the folds of the bodice. The dress itself is painted in shades of blue, with green and Parma violet, which give it a voluptuousness that is absent from the woman's figure. There is a sensuousness in the thick paint of the milky white coffee cup and the silver-grey of the little spoon and the coffee pot. The still life, placed next to the woman, is composed of vertical shapes and adds no sentiment to the painting. This is not a casual coffee break. These elements are simply there to 'correct' the verticality of the figure in relation to its surroundings – a background of moulded wooden panels (either a cupboard or a door) and a wall covered with a flowery wallpaper, which seems slightly off-centre on the left. This thoughtfully balanced composition echoes the image of immutable time, symbolized by this large hieratic figure. The same sculptural monumentality is also found in some of Degas's portraits from this period.

Woman with a Coffee Pot,
detail

*Woman with a Coffee Pot, c.*1895
Oil on canvas, 130 x 97cm
musée d'Orsay, Paris
(Gift of M. and Mme Jean-Victor Pellerin)

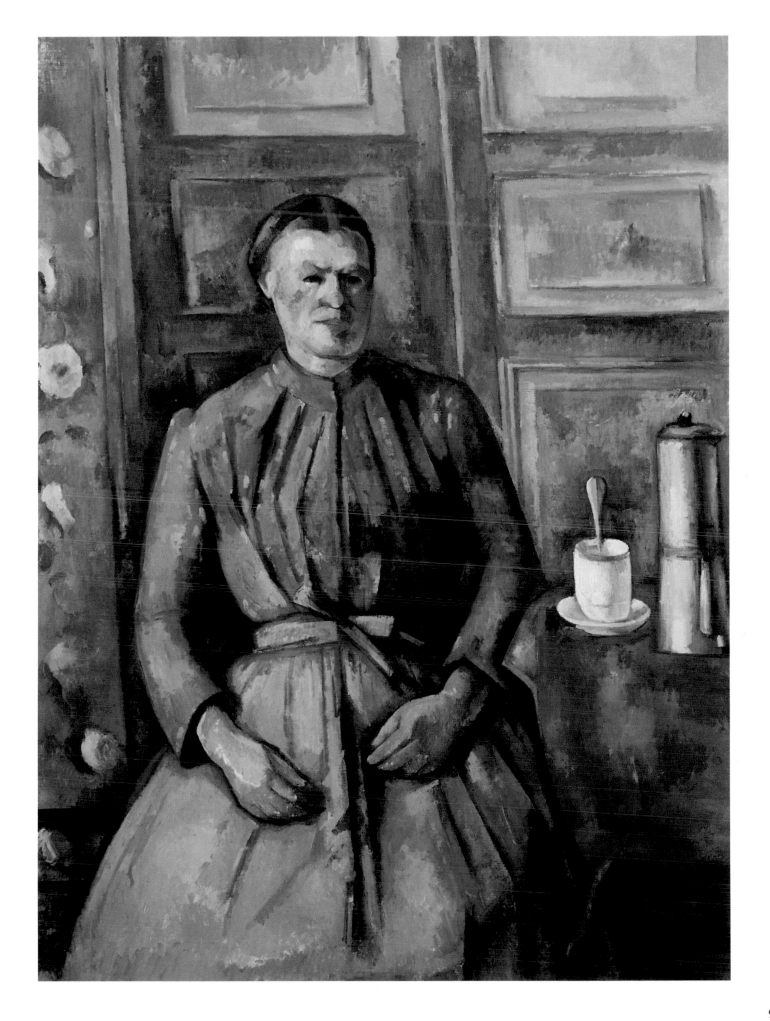

Portrait of Gustave Geffroy

ON 25 MARCH 1894 the critic Gustave Geffroy (1855–1926) wrote a flattering article about Cézanne in *Le Journal*. At that time the two men did not know each other, but they met a few months later, on 28 November 1894, at a reception organized by Monet, to which Clemenceau, Rodin and Octave Mirbeau were also invited. Cézanne was then at a key period of his career and on the point of being recognized as a major artist with the retrospective exhibition of his work at Vollard's gallery. Despite this, he remained a timid man, jealous of his privacy. He trusted Geffroy, however, and appreciated his review. Two months after their first meeting, the painter thanked him for both the dedication and content of his book *Le Coeur et l'Esprit*, in which he recognized some of his own views about art. On 4 April 1895 he began Geffroy's portrait, on which he worked until the end of June, visiting Geffroy's home at Belleville almost daily.

Geffroy is shown in his familiar surroundings of books and pamphlets. His eyes are raised from his work, perhaps an article, as he briefly looks up. Perhaps coincidentally, this composition is reminiscent of Degas' portrait of the writer and critic Edmond Duranty, which had been exhibited in 1879 at the fourth Impressionist exhibition and which Cézanne is almost certain to have known. The background of many coloured books and the cluttered desk

in the foreground appear in both works, but the still and solemn figure of Geffroy has less spontaneity than Degas' depiction of Duranty. On the left of Geffroy's desk Cézanne has included a little plaster statue by Rodin showing Pomona with a rose. He worked on all the elements of the painting simultaneously, but left the face until last. He then suddenly renounced the work, although Geffroy insisted that he finish it. It is impossible to say if Cézanne's decision was due to a sudden change in his mood or if some tension had arisen between the two men that prevented Cézanne from completing the portrait. In June 1894 Cézanne wrote to Geffroy to beg his pardon: 'I am unable successfully to complete this work, which is beyond my abilities and which I should not have undertaken – I beg you to forgive me.' He was, as he confided to Monet a few weeks later, very dissatisfied with the work: 'For the moment I have had to give up the work I had been doing at Geffroy's house. He had so generously put himself at my service that I am rather ashamed of the slight result I have achieved, particularly after so many sittings and after having been, alternately, so enthusiastic and so despondent.'

In the end the canvas was never completed, and Cézanne abandoned it at Geffroy's house. The relationship between the two men quickly grew acrimonious, possibly after

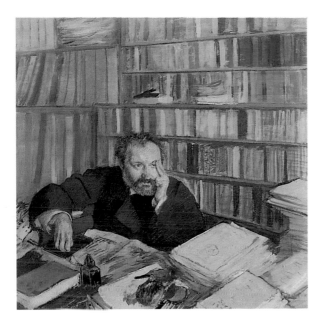

Edgar Degas, *Portrait of Edmond Duranty*, 1879
Tempera and pastel on canvas, 100 x 100cm
Burrell Collection, Glasgow Art Gallery

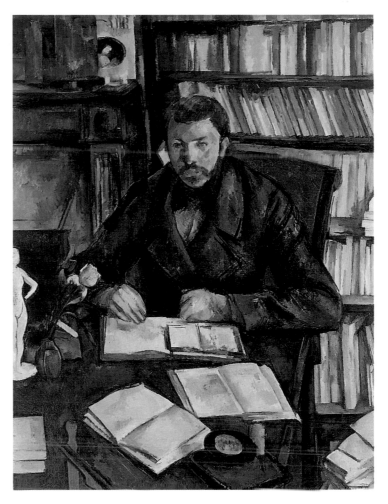

Portrait of Gustave Geffroy, 1895
Oil on canvas, 116 x 89cm
musée d'Orsay, Paris

an exhibition at Vollard's gallery, when the sudden attention paid by critics to his work helped to reinforce Cézanne's mistrust of critics and his increasing determination not to be exploited. A note written in 1903 reveals the painter's enduring disappointment with the critic: 'How could such a distinguished critic allow himself to be castrated of his feelings? He has become a businessman.'

The unfinished portrait is a good example of Cézanne's method of applying successive thin layers of colour. The zigzag lines give the composition a bold equilibrium that derives from the way the various tensions balance each other out. The geometric yet lively handling of space gives the portrait an exceptional density.

Still Life with a Plaster Cupid

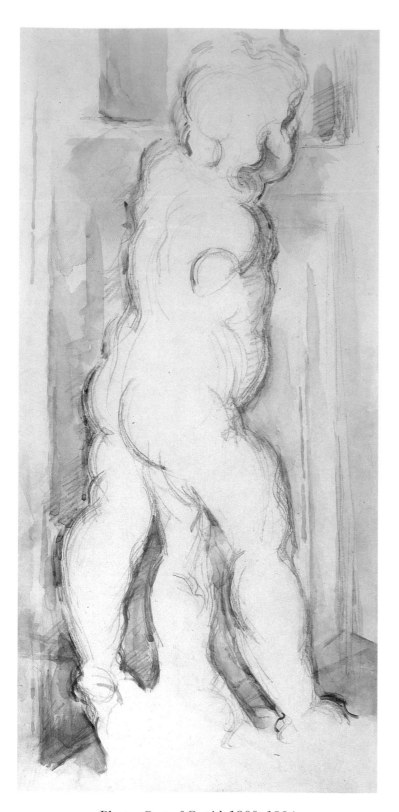

Plaster Cast of Cupid, 1900–1904
Pencil and watercolour, 47 x 22cm
Collection of Mr and Mrs E.V. Thaw, New York

CÉZANNE MADE HIS FIRST DRAWINGS of Cupid in the mid-1870s, which suggests that by the time he came to work on this composition he had had the plaster cast in his possession for a considerable period. This familiar statuette, of which the original was wrongly attributed to Puget or to Coustou, is the focal point of this still life, mediating the transition from the foreground to the background, where a corner of the artist's studio is obscured by canvases resting on the floor and facing in all directions. At the top right of the composition and half cut off by the edge of the canvas Cézanne has placed another plaster cast he kept in his studio. This is an écorché (a figure used for anatomical studies), which was once attributed to Michelangelo and of which Cézanne produced many studies. (Plaster casts of anatomical details or of works of sculpture were common properties in the studios of nineteenth-century artists.)

The presence of paintings within a painting introduces a sophisticated puzzle of motifs within motifs. It is only with difficulty that the viewer can discern and identify the different elements of the composition. The transition from the still life in the foreground and the painting behind it, in which there are the same items – blue drapery and apples – is scarcely perceptible, and one might almost think that the one is an extension of the other. The edge of the stem of the onion near

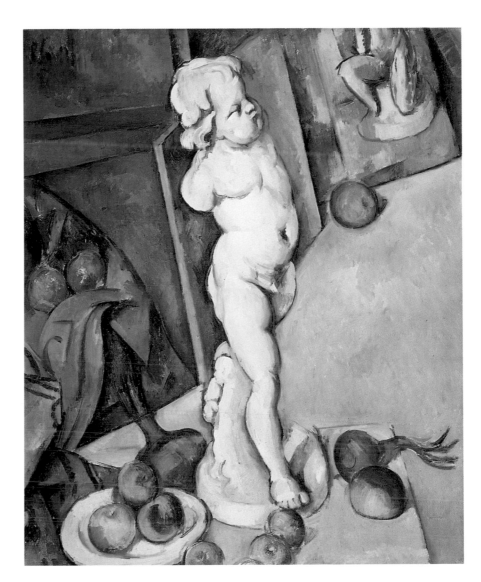

H. Bayard, *The Artist's Studio, c.*1845
Société Française de Photographie, Paris

*Still Life with a Plaster Cupid, c.*1895
Oil on paper, 71 x 57cm
Courtauld Institute Galleries, London

the base of the statuette is deliberately confused with the bottom line of the canvas to reinforce the illusion. Surrounded by apples, whose erotic symbolism was analysed by Meyer Schapiro, and by onions, whose shapes are no less suggestive, Cupid rises triumphantly. Although the statuette is only little, its luminous, slight bluish colour dominates this vertiginous composition.

Lac d'Annecy

IN JULY 1896, at the request of his wife and son, Cézanne spent a holiday by the lake at Annecy. The family stayed at a former convent, the Hôtel de l'Abbaye, in Talloires, but Cézanne was soon bored, as he told his childhood friend Philippe Solari: 'When I was in Aix I thought I would be better somewhere else. Now I am here, I miss Aix. I have started to find life deadly dull. ... I have begun to paint to distract myself – it is not funny – but the lake is beautiful, with the mountains around it. I'm told they are 2,000 metres high. It is not a patch on the countryside around our home, although it is quite pleasant to be without any responsibilities.'

The small summer resort of Talloires is situated on the narrowest part of the lake, at the foot of the high mountains to which Cézanne referred in his letter. He also described the picturesque view to his young friend from Aix, Joachim Gasquet: 'This place has a temperate climate. The mountains are fairly high. The lake at this point narrows to a bottleneck and seems to lend itself to the line drawing exercises practised by young ladies. It is nature, of course, but a little as we have been taught to see it through the albums of young lady travellers.'

Clearly he was not enthusiastic about the lakeside landscape that he was exploring or perhaps he was missing his studio and the countryside around Aix. Nevertheless, he worked on a number of watercolour sketches, swiftly noting down on paper the reflections of the water and the views of the surrounding mountains. When he was back in Aix, he undertook this picture, the only known landscape inspired by his holiday in Annecy.

The Château of Duingt, which stood on the opposite shore of the lake from Talloires, stands out in the background, while a large tree in the foreground frames the subject. The oppressive feeling imparted by the high mountains and the deep lake are conveyed by a saturation of cold colours – blue, verging on black, and green, shading to a dark emerald tone – and by the network of lines. The sky is not visible in the dark, dramatic landscape.

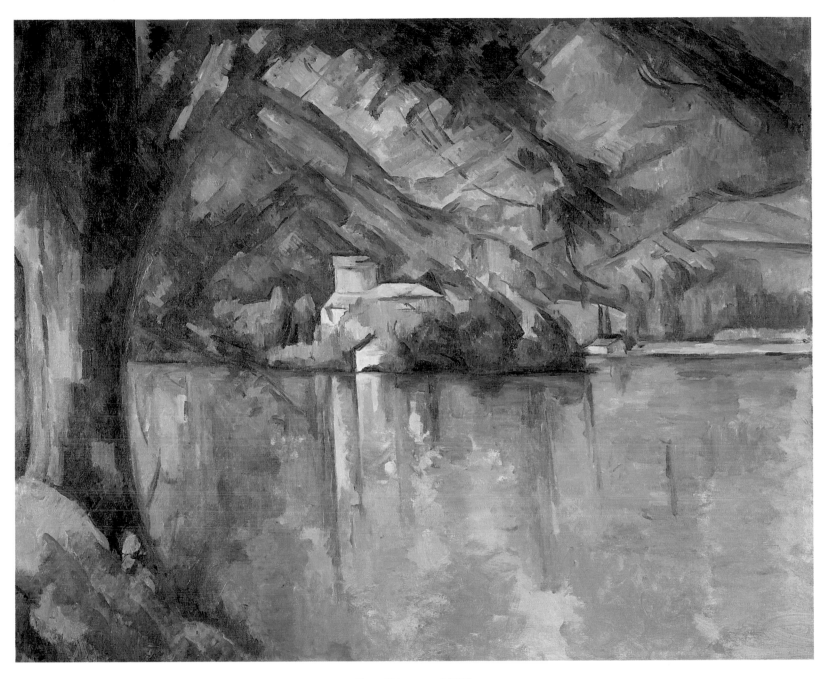

Lac d'Annecy, 1896
Oil on canvas, 64 x 81cm
Courtauld Institute Galleries, London

Portrait of Ambroise Vollard

Apart from a few youthful works depicting his friends or Hortense Fiquet, Cézanne completed few portraits of his acquaintances. Like the portrait of Geffroy (see page 97), this depiction of Ambroise Vollard (1865–1939) is, therefore, somewhat exceptional. The two men had met three years earlier, and at the time the portrait was begun, Vollard was Cézanne's exclusive dealer. In 1895, with the help of Cézanne's son, Vollard had organized the first retrospective exhibition of the artist's work in his gallery in the rue Laffitte, and his relationship with the painter was so good that he had asked him to paint his portrait. Vollard left an account of the experience: 'He agreed to my request and gave me an appointment for the following day in his studio in the rue Hégésippe-Moreau. When I arrived I saw, in the centre of the studio, a chair placed on a box that was itself balanced on four spindly supports. I was looking at this platform with a certain amount of anxiety, when Cézanne, noticing what I was looking at and guessing the cause of my concern, said: "I positioned the chair for the sitting myself. You don't run the slightest risk of falling, M. Vollard, as long as you keep your balance. Anyway, when you are sitting, you are not meant to move." Once I had sat down – which I did with some care – I made quite certain that I didn't make any awkward movements. What is more, I kept absolutely still.

In fact, this immobility made me feel quite drowsy, and although I struggled successfully for quite a while, in the end, my head fell on my shoulder and I stopped being aware of the outside world. Suddenly, I lost my balance, and the chair, the box and myself collapsed on the floor. Cézanne rushed over to me, crying: "You wretch, you have ruined the pose. Do I have to tell you again, you must sit like an apple? An apple doesn't move, does it?"'

The overwhelming pressure felt by Vollard in these sessions is not evident in the portrait. The sitter is shown face on, in a studiedly relaxed pose. Apart from the white shirt, the portrait is in harmonious tones of neutral and dark colours, bluish-grey and earthy shades, which are appropriate for a dull, grey day. Cézanne wrote to his sitter: 'M. Vollard, I have some good news for you. I am rather pleased with the work I did earlier on [his afternoons were devoted to his studies in the sculpture galleries of the Louvre or the Trocadéro, while the mornings were spent working on the painting], and if the weather tomorrow is overcast, I think that the session will be a good one.'

Vollard claimed to have endured more than a hundred sittings for the portrait, and he relates in his memoirs: 'His last words as I was leaving were: "I am not unhappy with the front of the shirt." He made me leave the clothes

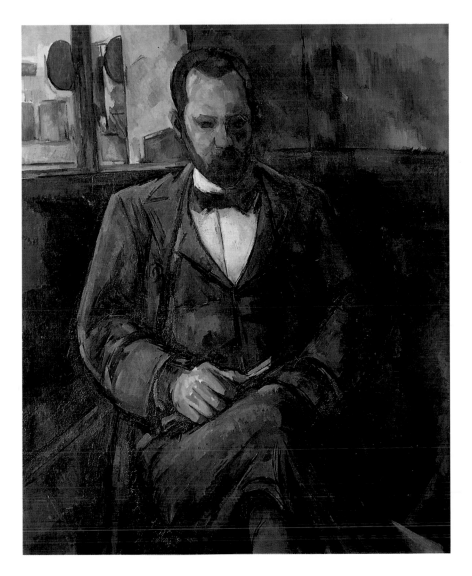

Portrait of Ambroise Vollard, 1899
Oil on canvas, 100 x 81cm
musée du Petit Palais, Paris
(Gift of Ambroise Vollard)

I wore for the sittings in his studio because when he came back to Paris he planned to block out the two little white spots on the hands and then, of course, work over other areas. "I will have made some progress before then," he said. "You do understand, M. Vollard, don't you, that the outline keeps on evading me." But when he was talking about going over his work, he had forgotten about the blasted moths that had made holes in my shirt.' These mishaps did not deter Vollard from sitting for his portrait on other occasions, however, and he later sat for Renoir, Bonnard, Picasso and Matisse. Of all the portraits for which he sat, the one by Cézanne is the only one to suggest elegance and charm, attributes that seem to have been lacking from Vollard's character. In addition to the personal qualities of the sitter, this portrait reveals the scrupulousness with which Cézanne sought to convey the inner feelings of his sitter, even if those feelings were more a reflection of his own state of mind than of the subject.

Pyramid of Skulls

DANTE: Tell me, mon cher, what are they eating?
Virgil: It is, in fact, a skull.
Dante: My God, that's horrid. Why are they gnawing at that disgusting brain?
Virgil: Listen, and you will find out ...

Cézanne wrote the long, macabre poem *La Mort règne en ces lieux* ('Death Reigns Here') to Zola on 17 January 1859 because he could not think of 'any beautiful things' to write. It was accompanied by Cézanne's first representation of a skull – a skull being shared among cannibals. Although the painter had been interested in funereal paintings since his youth, he had produced only two *vanitas* (still lifes with a skull) – *Still Life with Skull and Kettle* (1865–1867) and *Still Life with Skull and Candlestick* (1865–1867) – and there is a skull in *Mary Magdalene* (*c.*1867, see page 43). Cézanne was obsessed with the idea of death, even though it was not a central theme of his

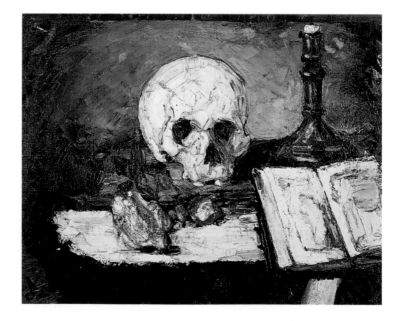

Still Life with Skull and Candlestick, 1865–1867
Oil on canvas, 47 x 62cm
Private collection

paintings. He found an echo of his own obsession with the idea of death as a lover and the inevitable consequence of love in the poems of Baudelaire. He abandoned the subject for about fifteen years, then returned to it with a vengeance, introducing skulls into paintings, sketches and watercolours. His correspondence reveals that he was haunted by thoughts of his own death. The continual friction within his own family led him to make his first will in 1882, and in 1878 he had written to Zola about his premature death: 'The man who brought me into this world is obsessed with the idea of freeing me. There is only one way to do this, and that is to throw me two or three thousand francs more each year and not to postpone making me his heir until after my death, for I am sure my end will come before his.' These macabre thoughts were translated to canvas in the mid-1890s with the representation of a young man meditating in front

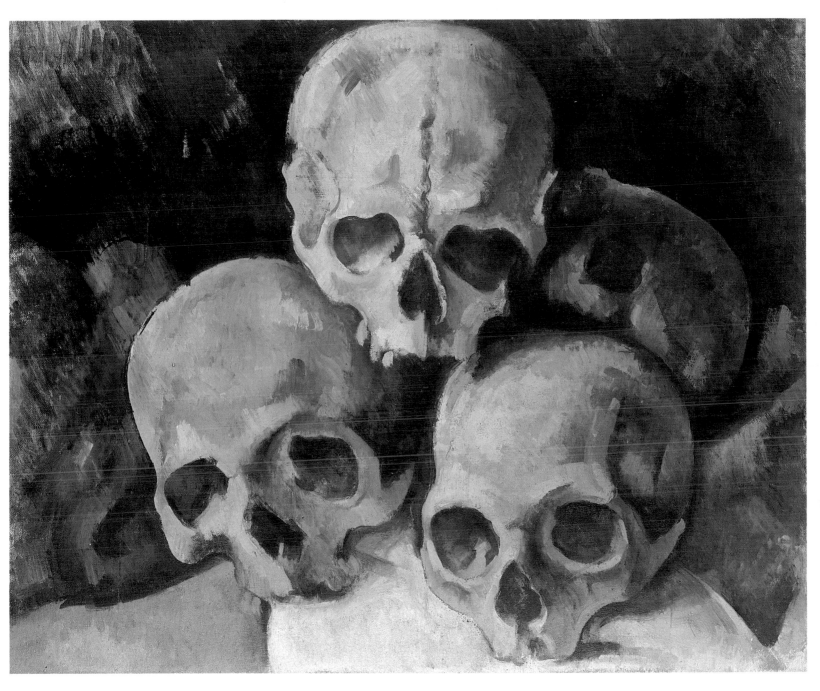

Pyramid of Skulls, 1898–1900
Oil on canvas, 37 x 45cm
Private collection

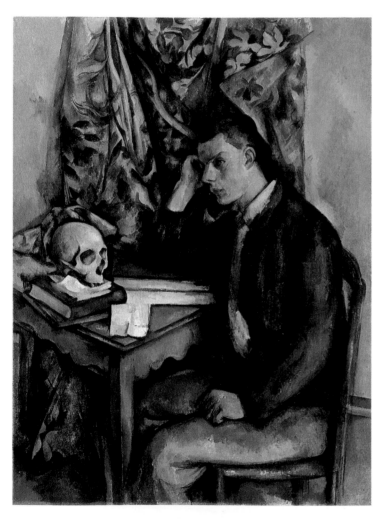

Young Man with a Skull, 1894–1896
Oil on canvas, 130 x 97cm
Barnes Foundation, Merion, Pennsylvania

of a skull, which was in the style of seventeenth-century genre paintings or works showing Hamlet's meditation. The skull, which he had for so long abandoned as a motif, became one of his chief subjects during the last years of his life.

It was not simply the symbolism of the skull that fascinated him. He was interested in its shape, which he showed in different ways: sometimes a single skull; sometimes several skulls, lined up or piled up; sometimes accompanied by decorative motifs; sometimes seen in profile and sometimes full on. The ways in which he rendered the roundness of the forehead and the occiput and the sockets sometimes obscure the emblematic power of the object itself. Gasquet noted that 'in his last days he was thinking through his ideas about death as he formed skulls into heaps so that the eye sockets gave off a bluish glint.'

Cézanne's simplification and stylization of the shape of the skulls retain only the essentials – the teeth and lower jaw are never depicted. He had several human skulls in his studio, and he used to arrange them as if they were fruit in a still life – there is nothing frightening or moralistic about the arrangements. After using skulls to express his own anguish during his romantic period, Cézanne stripped them to their absolute basics in these serene compositions, where they are represented without a trace of pathos.

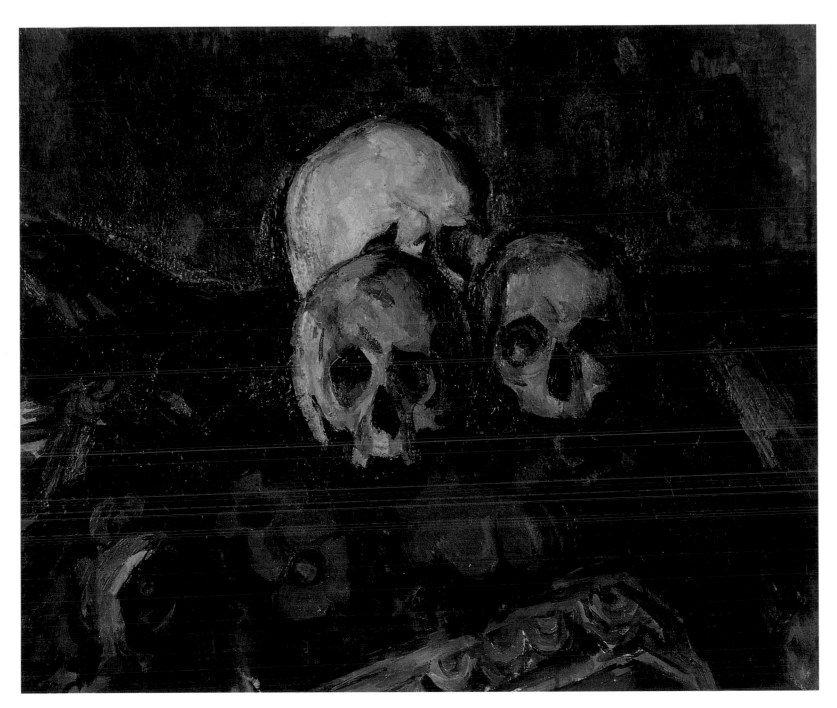

Three Skulls on an Oriental Rug, 1898–1905
Oil on canvas, 54 x 64cm
Kunstmuseum, Soleure

Portrait of the Gardener, Vallier

APART FROM THE BATHERS, the only figures painted by Cézanne during the last years of his life were portraits of men and women of middle age or beyond. He surrounded himself with young friends but preferred to paint people of his own generation. In 1902 he told the archaeologist Jules Borély: 'It is in the eyes of people of my own age that I see the past once more. Above all, I love the look of people who have grown old without abandoning the old customs, of people who have lived their lives in accordance with the laws of time. I despise those who attempt to overcome those laws. Look at the old man who owns that café, sitting on his doorstep under that spindle tree. What style! And now look at the girl shop assistant. Of course she is pretty, and there is nothing to say against her – but her hair and her clothes are so banal and deceitful.'

Cézanne liked the patina that time gave. He hated artificiality and progress. The people who were close to him and served him in his old age – and whom he trusted – were Mme Brémond, his housekeeper, and Vallier, his gardener. Vallier sat for him several times, wearing a straw hat or a sailor's hat. He was probably working on one of these portraits, which remain unfinished, a few days before he died. On 28 September 1906, shortly before his death, he wrote to his son: 'I still see Vallier, but I am so slow at my work that it saddens me.'

Despite this declaration, the broad, dynamic brush strokes of this painting reveal nothing of the painter's difficulties. He chose a range of sombre, dark tones – greens and blues – that are in keeping with the elderly sitter. The rather solemn pose and slightly overwhelmed expression on the man's face make the portrait an archetype of old age, and Cézanne's humanity irresistibly calls to mind the faces of old people painted by Rembrandt.

Portrait of the Gardener, Vallier, 1905–1906
Oil on canvas, 107 x 75cm
National Gallery of Art, Washington D.C.
(Gift of Eugène and Agnès E. Meyer)

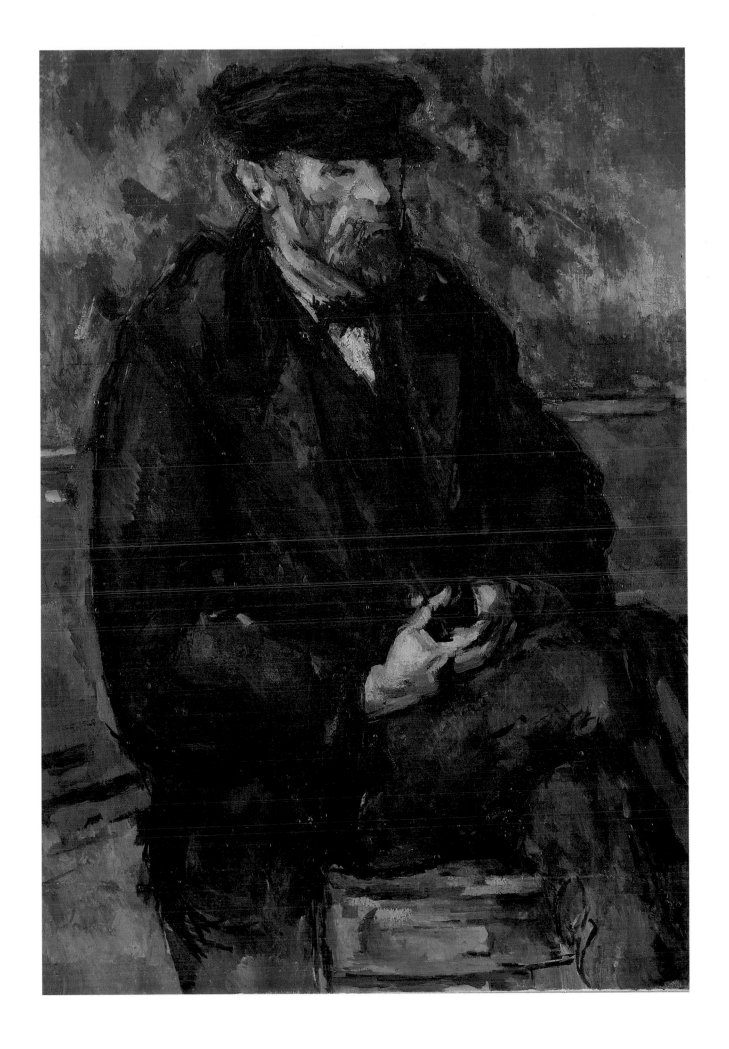

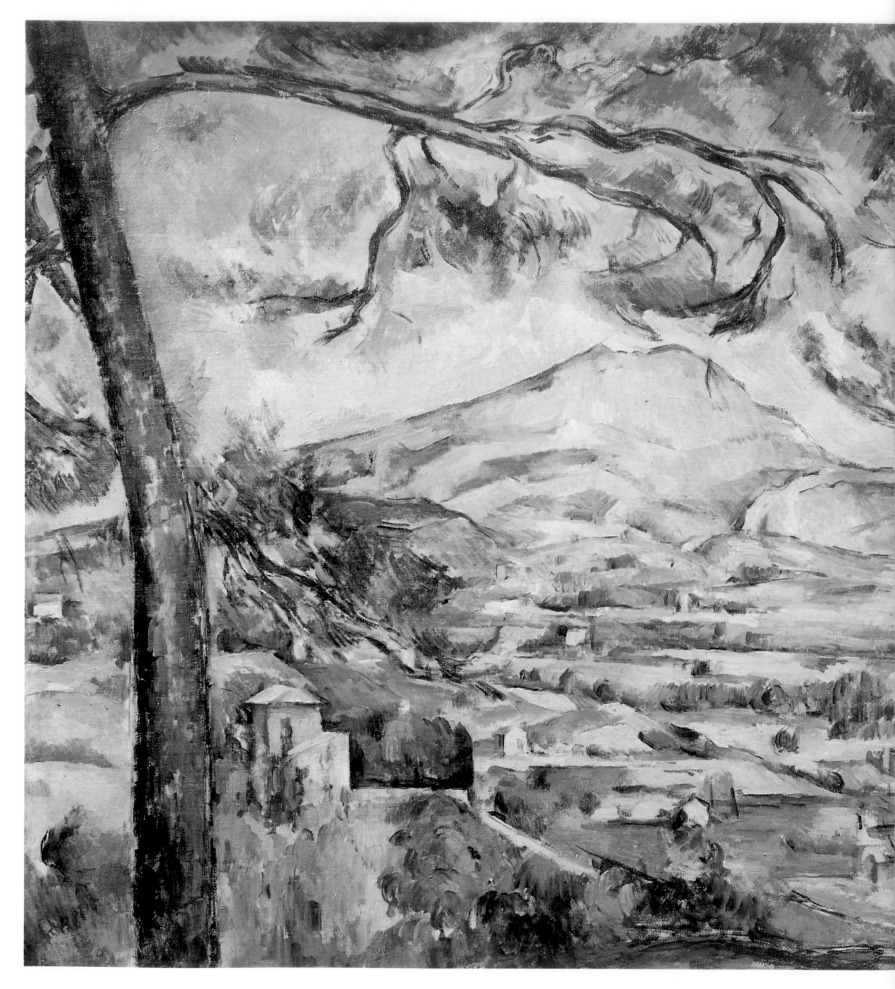

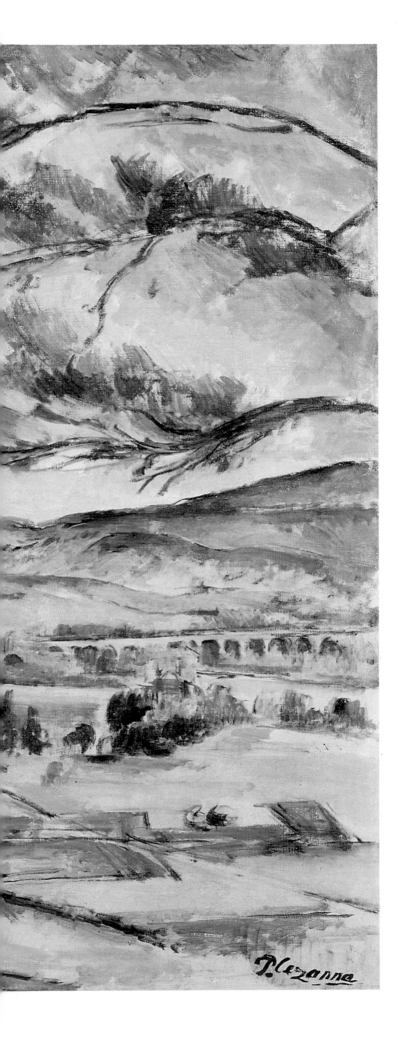

Mont Sainte-Victoire

Mont Sainte-Victoire, 1885–1887
Oil on canvas, 66 x 90cm
Courtauld Institute Galleries, London

It is thought that the name of the mountain, Victoire, derives from *ventus*, the Latin for 'windy.' Hermits have lived on the mountain since ancient times, and they built a chapel in the rock. In the seventeenth century the ruined building was restored, and a new oratory, dedicated to Notre-Dame de Victoire ('Our Lady of Victory'), was built, together with a priory that, although dilapidated, was in existence until 1880. In the nineteenth century people used to make excursions to visit the ruins of the chapel.

Cézanne's association with the mountain began when he was a child. With his friends, he used to climb the steep, rocky sides and experience the solid reality of the mountain for himself. As an adult, in addition to the passion he felt for the place itself, he was fascinated by the mountain's iconic meaning as a symbol of the genesis of the world. From his conversations with the painter, Émile Bernard had the impression that there was an almost mystical relationship between Cézanne and the mountain. 'Look at Mont Sainte-Victoire,' he had said. 'Is it not a ruin? Does it not signify all the events that have taken place since the Creation? Where can one

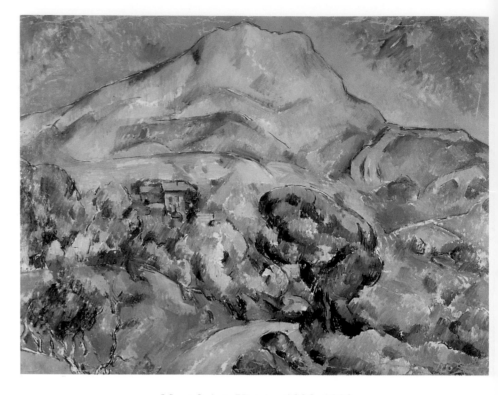

Mont Sainte-Victoire, 1896–1898
Oil on canvas, 81 x 100cm
Hermitage Museum, St Petersburg

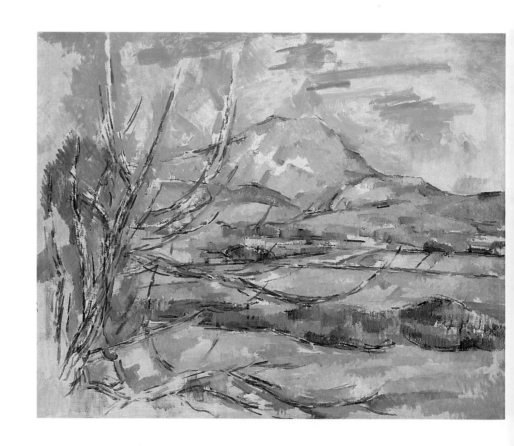

Mont Sainte-Victoire, 1900–1902
Oil on canvas, 55 x 65cm
National Galleries of Scotland, Edinburgh

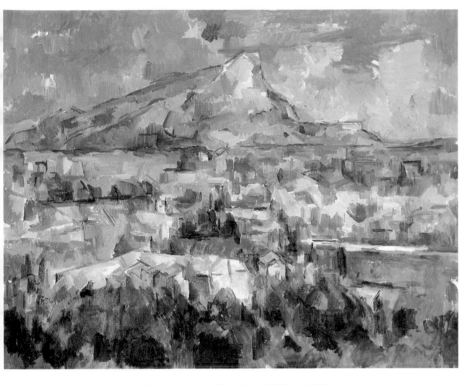

Mont Sainte-Victoire, 1902–1906
Oil on canvas, 70 x 90cm
Museum of Art, Philadelphia (George W. Elkin Collection)

find the whole of nature after it has experienced chaos? One must accept that the artist carries in his soul a yearning for this lost harmony and that he tries to rebuild it from the magnificent fragments that he sees in front of him as if God were testing his intelligence.'

More prosaically, Joachim Gasquet thought that Cézanne regarded the mountain as an aesthetic challenge, and that the artist had continually to scan its form, its colours, its rocks and its light. He put into his own words what Cézanne had said to him. 'What vigour, what a majestic quest for the sun and how great a melancholy in the evening, when this great mass sinks down again. ... Those blocks seem to be on fire. The fire still burns in them. In daylight the shadows seem to draw back in terror, afraid of those glowing rocks. Plato's cave is up there. You will notice how, when large clouds pass overhead, the shadows that fall from them tremble on the rocks as if they have been burnt or swallowed up in a cauldron of flames. For a long time I could not paint Mont Sainte-Victoire because, just like people who do not look at it, I thought that the clouds were concave, but

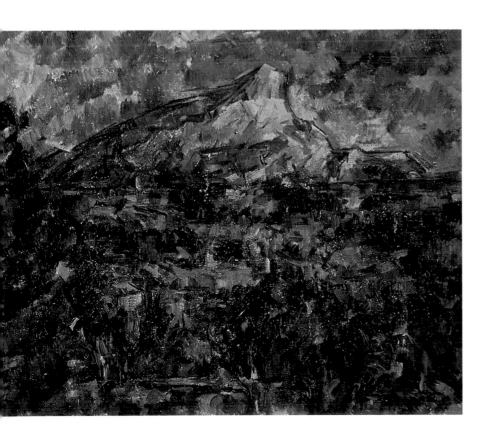

Mont Sainte-Victoire, 1905–1906
Oil on canvas, 60 x 73cm
Pushkin Museum, Moscow

Mont Sainte-Victoire, 1896–1898, detail
Hermitage Museum, St Petersburg

instead, look, they are convex and draw away from its centre.'

Unlike Monet, who had been interested in the appearance of his subject matter according to the time, season or weather, Cézanne wanted to produce a synthesized image, one that expressed the absolute nature of the object rather than the variations that occurred in different kinds of weather or in different light.

It was this quest for the essence of the subject that led to Cézanne's solitary confrontation with the mountain. When he first included Mont Sainte-Victoire in his compositions it was only one element of the overall landscape. After staying at Gardanne in 1886, however, Cézanne began work on a series of panoramic views in which the mountain dominated the countryside. The mountain's silhouette was often framed in the foreground by the trunks and branches of pine trees. From about

1890 until his death, whenever he was in Aix, he would set off on the path up the mountain almost every day, walking along its steep sides. He was fascinated by the folds in the rocks and translated them onto his canvases in strongly defined lines and outlines, creating an increasingly complex network of overlapping planes. His vision, drawn rather than painted, resembles a winter landscape, in which nature is bare and everything stands out clearly in the cold, clear air. In summer, on the other hand, when the intense heat makes the air tremble, the landscape becomes a kaleidoscope of colours and forms, and if it were not for the recognizable outline of Mont Sainte-Victoire, the paintings would be almost abstract.

In October 1905, a year before his death, Cézanne confided to Émile Bernard that he found it difficult to render the transition from one plane to another. 'Now I am old – almost

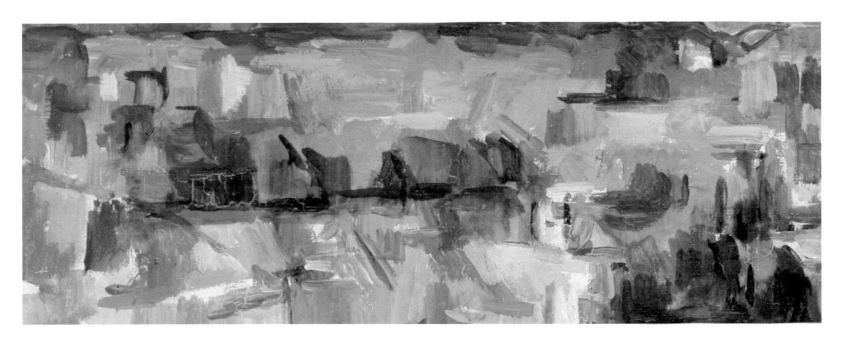

Mont Sainte-Victoire, 1902–1906, detail
Museum of Art, Philadelphia (George W. Elkin Collection)

seventy – the colours that produce the light create abstract shapes that do not allow me to cover my canvas or, whenever the contrasts are subtle or delicate, prevent me from depicting the subject clearly. As a result, my image or picture is incomplete.'

It was, nevertheless, as a result of his efforts to portray the mountain that Cézanne was able to write to Bernard in April 1904: 'Render nature by means of the cylinder, the sphere and the cone, all put in perspective – that is, so that each side of an object or plane is directed towards a central point. The lines that are parallel to the horizon create distance, which is one aspect of nature. ... The lines that are vertical to the horizon give depth. For us mortals, however, nature is far more than just the surface, and this is why, in order to help us feel the atmosphere, we have to introduce blue tones in to the light, whose move-ment is represented by reds and yellows.' Cézanne returned time and again to Mont Sainte Victoire, almost as if it were the Sphinx and he were seeking the answer to a question. He was acutely aware of both its presence and its shape, and we find echoes of that pyramidal arrangement of mass, reaching to the sky and grown from the depths of the earth, in all his compositions, still lifes and bathers alike. The mountain stands immutable and challenging above the instability of the world and the inconstancy of human nature, holding within itself the secrets of nature that Cézanne sought to comprehend. He saw in its eternal form the divine and transcendental origins of art. It was where he attempted to understand those eternal enigmas. He studied it and transferred it to canvas so often that the mountain has come to signify his achievement.

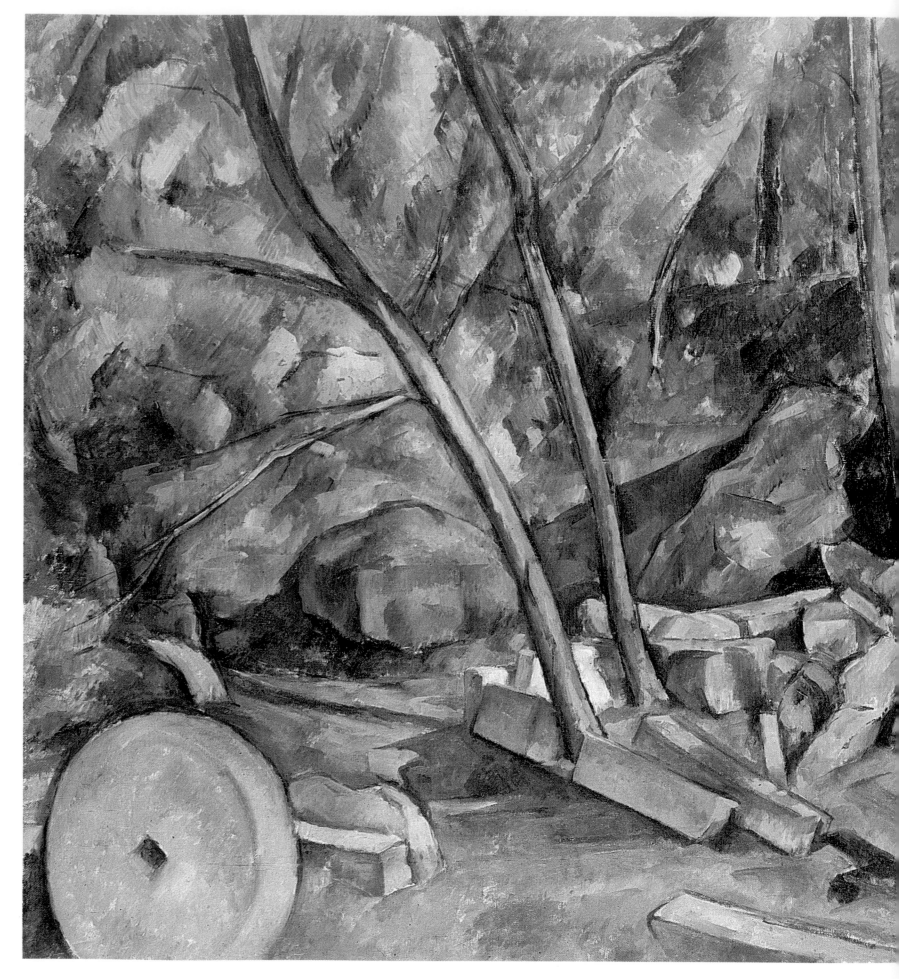

The Last Themes

The Millstone in the Park of Château Noir, 1898–1900
Oil on canvas, 73 x 92cm
Museum of Art, Philadelphia
(Mr and Mrs C.S. Tyson Collection)

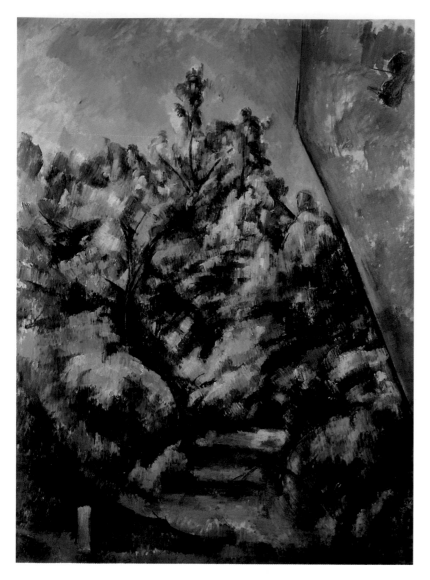

*The Red Rock at Bibémus, c.*1900
Oil on canvas, 92 x 68cm
musée de l'Orangerie, Paris
(Jean Walter and Paul Guillaume Collection)

AT THE BEGINNING OF SUMMER in 1897 Cézanne rented a small country house at Le Tholonet, a village at the foot of Mont Sainte-Victoire, in order to paint landscapes and the quarry at Bibémus, and he worked there until September. According to a letter written by his friend Numa Coste to Zola on 5 March 1897, it was a sad period in the artist's life. 'Cézanne is very depressed and is tormented by dark thoughts, even though he has cause to be pleased with himself and his paintings are selling better than ever before. His wife must have made him do some really stupid things. ... He has rented a cottage near the quarry by the dam and spends most of his time there.' This retreat brought Cézanne some temporary consolation. He would walk there every morning, returning in the evening to his house in Aix where his mother was close to death.

The quarry at Bibémus, with its ochre stones, was not far from the swallow hole of Les Infernets, which Cézanne and Zola had explored together when they were children. He went back there to work, drawn by the intractable geometry of the stones and the complex tangle of vegetation that grew freely over the abandoned site. The contrast between the rampant, disordered lines of the plants and the rigid, barren forms of the rocks is reinforced by the contrasting colours – green and orange. The jumble of lines and

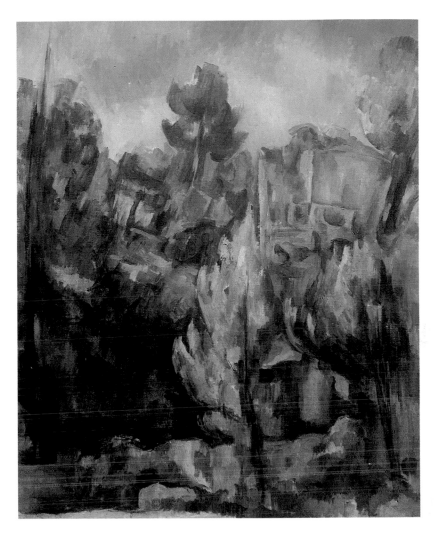

The Quarry at Bibémus, c.1900
Oil on canvas, 65 x 54cm
Private collection

tones that pervade the entire canvas, like a colourful tapestry, creates landscapes without subjects, landscapes that are almost abstract compositions. Cézanne concentrated to the exclusion of everything else on the combinations of shapes and colours and the contrasts of light and shade that enabled him to 'make us feel the weight of the air.'

Joachim Gasquet, writing in 1921, explained Cézanne's motivation. 'Cézanne was asking, first, that the laws of harmony reconcile him with himself. He was pursuing or searching for himself through them. ... He would put his whole being, his entire strength into each brush stroke. You have to have seen him painting – painfully tense and with a beseeching look on his face – to realize how much of himself he put into his work. His whole being trembled. He would hesitate, the veins on his forehead standing out as if swollen by his thoughts themselves. His chest would fill, his neck sunk between his shoulders, and his hands would shake until the very moment when, strong, certain and tender, they would place the paint on the canvas. Now there was no hesitation as the brush was applied, always from right to left. He would then step back a little, considering carefully, before raising his eyes to the subject of the work. He would then look over the object, establishing links between it and its surroundings, penetrating

it, possessing it. His eyes would fix on a point, frighteningly. ... Minutes, perhaps a quarter of an hour, would pass. He would seem to be hypnotized, losing himself in his struggle to understand the meaning of the object, of the world itself, where man's will meets the eternal will and is either reborn or absorbed. He would tear himself from his reverie, quivering, and return to his canvas, to life, where he captured the tone of a mysterious emotion, ecstasy, a secret surprise. He would paint to assuage the anguish of his quest.'

Cézanne's paintings seem to be infused with a secret life of their own, and that impression is especially evident in the almost hallucinatory representations of Château Noir, a strange castle with neo-Gothic windows that was situated about midway between Aix and Le Tholonet. The Château had been built on the hillside, probably in the first half of the nineteenth century, and it consisted of two main buildings, placed at right angles, and the beginnings of an orangery, which was never completed. Behind the building rises Mont Sainte-Victoire. The Château's name derives neither from its coloration nor from any macabre incident in its history; it was named after one of its previous owners who was a dealer in animal black (bone black). It was also sometimes called the Devil's Castle, perhaps because of its slightly strange atmosphere – like that of *The House of the Hanged Man at Auvers-sur-Oise* – which may have been the result of its isolation. This name, the Devil's Castle, was in fact given to one of Cézanne's paintings, which was shown at the fifth exhibition of the Société des Amis des Arts d'Aix-en-Provence in 1906.

Cézanne worked on the site between 1899 and 1904. Léo Larguier, who visited Cézanne at Château Noir in 1900, described it: 'It was an old provincial house, with everything in a state of neglect. In the large, high rooms, from which the furniture had been removed and from whose windows you could look out on the wonderful countryside, you would see boxes of watercolours and sketches, canvases thrown against the wall, tubes of paint, like desiccated fruit – it was like one of those properties where the gates have been closed after the owner has died.'

Cézanne painted not only several views of the Château, which seemed to loom out of the vegetation, but also views of the courtyard with its pistachio and other trees and water tank and the rocks in the pine wood around the house. Even after the building of his studio on the chemin des Lauves, Cézanne continued to paint the familiar places around Mont Sainte-Victoire and on the banks of the River Arc, and he worked at Château Noir until 1904.

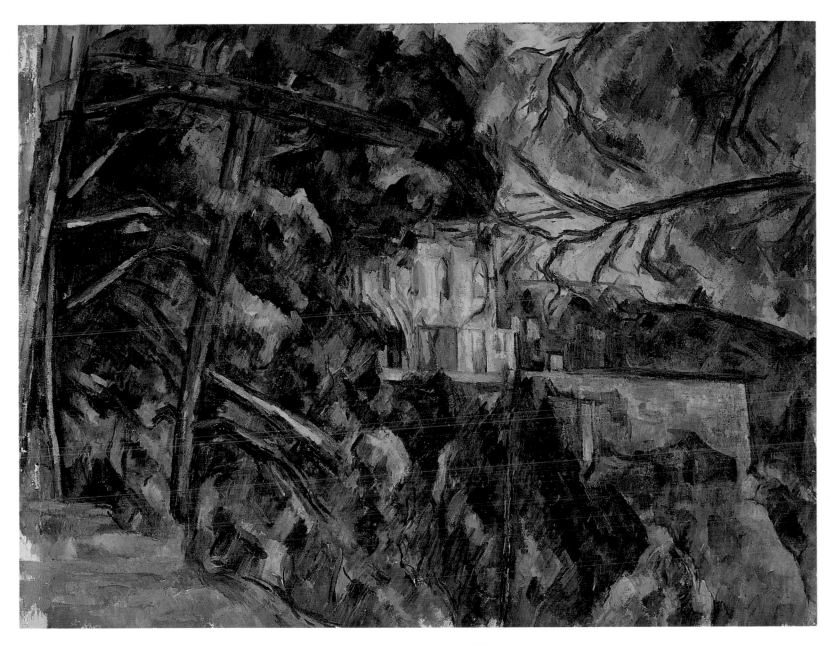

*Château Noir, c.*1900–1904
Oil on canvas, 74 x 97cm
National Gallery of Art, Washington D.C.
(Gift of Eugène and Agnès Meyer)

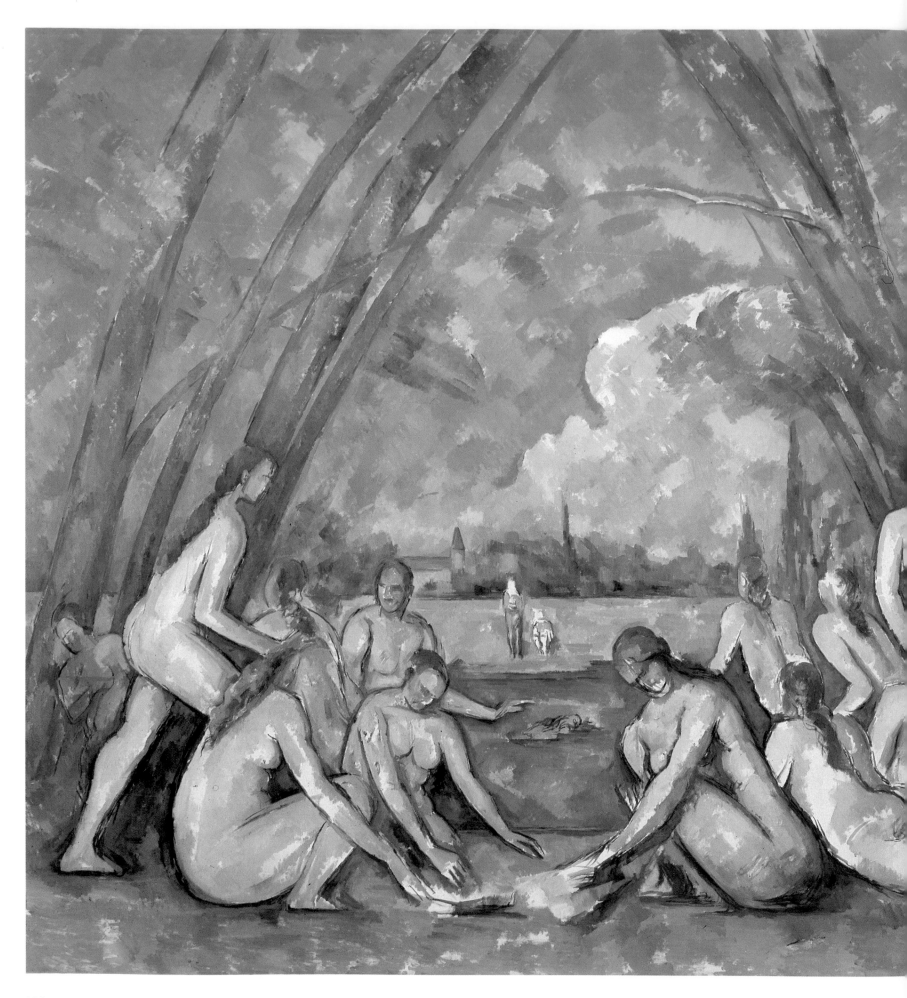

*The Large Bathers, c.*1906
Oil on canvas, 208 x 251cm
Museum of Art, Philadelphia
(W.P. Wilstach Collection)

Bathers

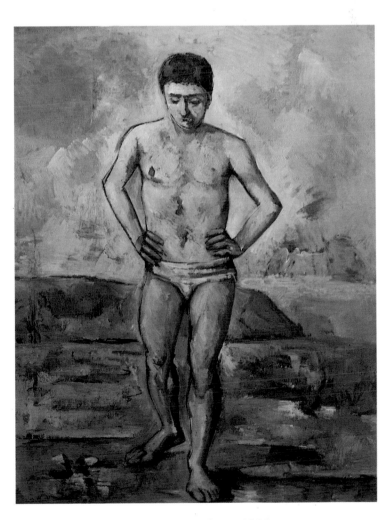

*The Large Bather, c.*1885
Oil on canvas, 127 x 96cm
Museum of Modern Art, New York
(Lillie P. Bliss Collection)

Five Female Bathers, 1885–1887
Oil on canvas, 65 x 65cm
Kunstmuseum, Basle

THE FIRST leisure scene that includes water appeared in Cézanne's works in the early 1870s, when he painted a pastoral scene with a group of clothed men resting by a river or lake accompanied by naked women. In that decade the artist began to work on the theme that he would continue to develop until the end of his life. Even earlier, however, the subject had interested him, and in a letter to Zola of 20 June 1859, illustrated with an anecdotal bathing scene, he reminisced about how young people used to enjoy bathing in the fresh waters of the River Arc near to Aix. Later, these motifs were translated into elaborate compositions, including elements borrowed from the Classics, when they were depicted as nymphs. Later still, the bathers became contemporary figures, losing all literary associations and often deliberately distorted, with elongated torsos and androgynous bodies. These figures instill a sense of alienation in the viewer: they are present in the landscape but there is no logical reason for their presence.

Soon Cézanne began to segregate the sexes in the paintings, and male and female figures never appeared in the same composition.

The number of figures varied from a single male figure, monumental and stiffly posed, to groups of three, four or even more figures. There are seventeen figures in *The Large Bathers* in the Museum of Art, Philadelphia (see pages 122–3).

The English critic Roger Fry noted: 'Cézanne does not have the gift of taking hold of an idea and expressing it with sufficient force to make it immediately apparent. It is as if he does not quite manage to develop his theme until he has completed the work. There is always something hidden behind what he expresses, something he would really like to capture if he could.' What, indeed, was Cézanne trying to express through this subject, on which he worked for more than thirty years? Was he seeking to portray the sensuality of the human form? The nudes in his early paintings of orgies and murders are distinctly more expressive and erotic than the bathers, with their apparently asexual bodies and theatrical but meaningless gestures. Cézanne was attempting to go beyond the portrayal of a conventional or classical subject, whether it was real, mythological or mystical. He wanted to portray the bathers

in situ, in a landscape; he did not want to create paintings in a studio. This paradox caused him countless problems, and towards the end of his life he tried to explain them to Émile Bernard. 'You know that I often made sketches of male and female bathers, which I would have liked to have painted, on a large scale, from life. Lack of a model forced me to be content with glimpses. There were other obstacles to overcome, such as finding somewhere to set the scene that would not be too different from the one I had imagined, of gathering together several people, of finding men and women who did not mind undressing and holding the poses I wanted. There were a thousand other difficulties, too, such as carrying around such a large canvas, the vagaries of the weather, the positioning of the canvas, the materials that would be needed to work on it. I was, therefore, forced to abandon my plan, which had been to revise Poussin from nature, rather than build up the composition from notes, drawings and fragmented sketches. I meant to create a real Poussin – from nature, working in the open air, with colour and light – not one of those works that are entirely conceived in the studio and that have that brown tone that indicates there was no daylight, no reflections from the sky.'

In 1895 Cézanne began a series of large canvases on which he worked until his death.

Three huge canvases with groups of bathers in landscapes with large trees represent one of the major pictorial testaments to future painters. One of these works, the largest, which is now in the Museum of Art, Philadelphia (see pages 122–3), is lightly painted and probably unfinished. The other two – one in the Barnes Foundation, Merion (see page 126), the other in the National Gallery, London (see page 127) – have, conversely, been worked and reworked so that the surfaces are thickly covered with paint. The subjects, boldly simplified into geometric shapes, have been built up with vigorous brush strokes. The female bodies, which are strongly outlined, are reduced to almost caricatured shapes and volumes, with angular arms and legs and oval, faceless heads. The bather lying to the right of the centre in the work in the National Gallery, London, has even been likened to a sea lion because of her huge, spindle-shaped body and flipper-like feet. There is no noticeable difference between the rendering of the figures and of the background. The reduction of the trees to crude geometric shapes echoes the stiff forms of the bathers. A cold, bluish tone suffuses the work, outlining the bodies and mottling them with shadows.

In the unfinished version (pages 122–3), there are unpainted areas all over the canvas, and they give the work its distinctive shimmer

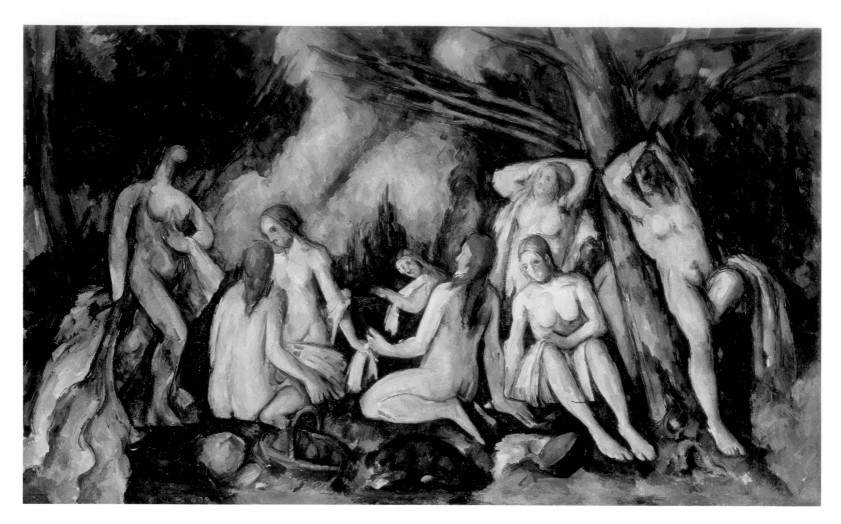

Bathers, 1895–1906
Oil on canvas, 133 x 207cm
Barnes Foundation, Merion, Pennsylvania

and feeling of light. In the other two paintings, the backgrounds are almost blocked out and filled with clouds, but in *The Large Bathers* the light tone of the far river bank, on which two figures and the church spire stand, looks welcoming and familiar. The patches of blue sky, seen between the tall tree trunks, give the scene a fresh, joyful atmosphere. The triangular construction draws the viewer's attention towards the central vanishing point on the distant bank, and the bathers, too, seem to be stretching forwards towards that point. One of

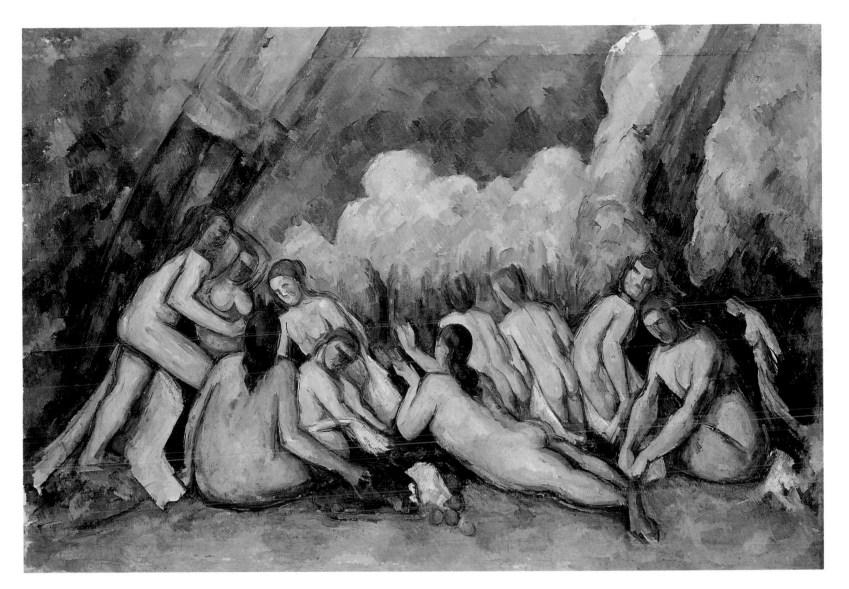

*Bathers, c.*1895–1906
Oil on canvas, 172 x 196cm
Trustees of the National Gallery, London

them is even crossing the river, but there is no sense of danger or menace. The impression is one of confidence and peace. The three bathers in the centre, who are petting the little dog, seem to be bidding it farewell before they, too, begin to cross to the other side. This masterpiece, whose huge size alone makes it unique, is Cézanne's last message to us.

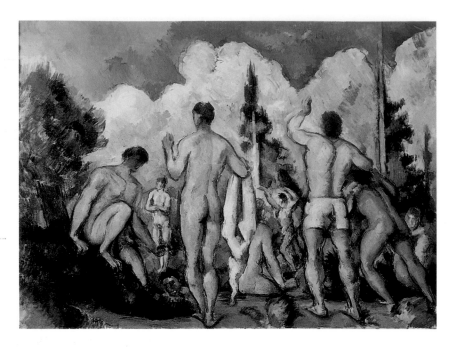

Bathers, 1892–1894
Oil on canvas, 60 x 82cm
musée d'Orsay, Paris
(Gift of the Baroness Eva Gebhard-Gougaud)

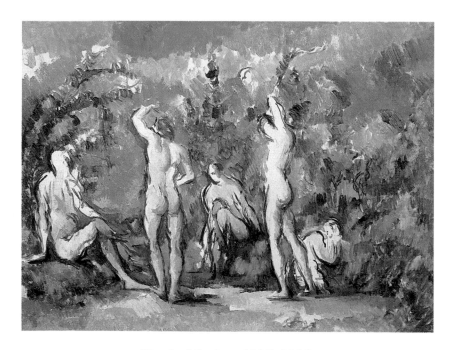

Sketch of Bathers, 1895–1906
Oil on canvas, 122 x 168cm
Stephen Hahn Collection, New York

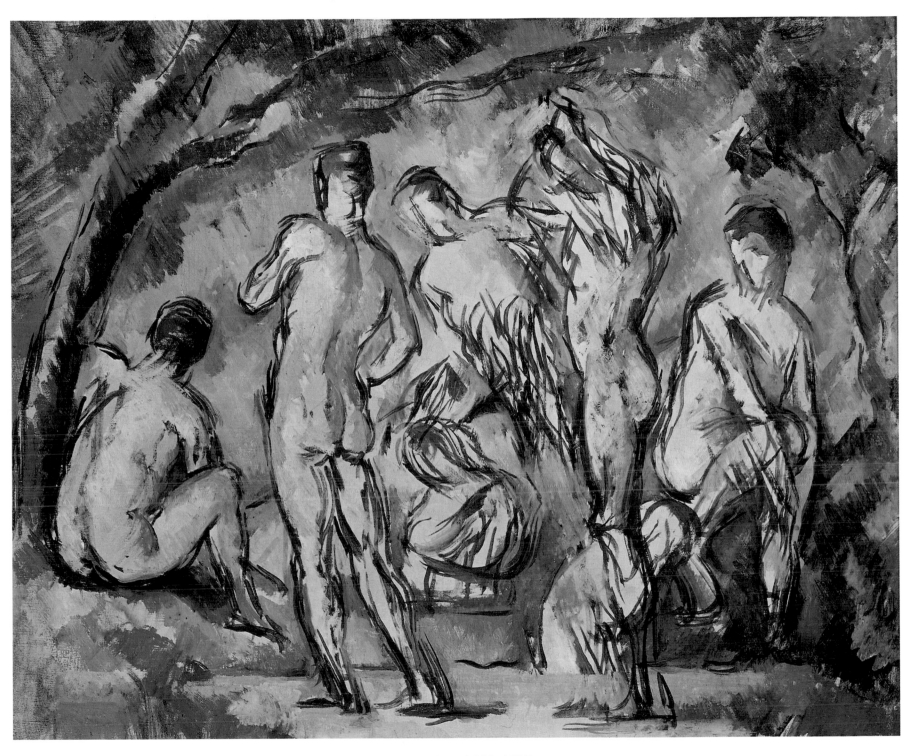

Seven Bathers, 1896–1897
Oil on canvas, 37 x 45cm
Ernst Beyeler Collection, Basle

Sketch Book

1888-1898

This small sketchbook (13 x 21cm), with its light brown canvas cover, contains thirty-two leaves, on some of which Cézanne has drawn on both sides. Apart from a portrait of his son and two studies that cannot be easily identified, the drawings in it were made from paintings, such as Titian's *Portrait of a Man* and Rubens' *The Apotheosis of Henry IV* (after Bellona), and sculptures in the Louvre. There are also copies of antique works and seventeenth- and eighteenth-century busts and group sculptures, and on the last page is a copy of the cast of the *Foolish Virgin* from Strasbourg Cathedral, which is kept in the musée de Sculpture comparée du Trocadéro.

Throughout his life Cézanne went to the Louvre whenever he could. During the 1890s he was an especially frequent visitor, making sketches that he could use in place of the living models he needed for his compositions, because he could not bear to work in another person's presence, not even a model's. When he was in Paris he visited the Louvre almost every afternoon, making sketches that would help in his quest to translate his feelings to canvas. These sketches were, in effect, a rehearsal for the paintings. On 13 September 1903 he gave the following advice to the painter Charles Camoin: 'You must keep good company. That is, you must go to the Louvre. But after you have seen the old masters who live there, you must leave quickly and bring to life the artistic sensations and instincts that lie deep within you.'

The drawings in the sketch book are not detailed studies. They are quick sketches, in which the pencil lines are frequently laid over each other, suggesting the shapes without enclosing the forms. The sense of relief, worked up from the inside, brings a feeling of vitality to the stone or bronze figures. These apparently simple studies reveal not only the artist's virtuosity – his strength of line, sense of detail and ability to suggest depth with the simplest line – but also his taste in art. The works demonstrate that a continuous line links Cézanne with the masters of classical art, who had themselves studied the masters of antiquity.

Page 6 verso, *c.*1895, *Bust of a Man*
The model for this sketch has not been definitely identified; it may have been the *Bust of Jean Gabaret* by Christophe Veyrier or the *Bust of Charles Le Brun* by Charles-Antoine Coysevox.
musée du Louvre, Paris

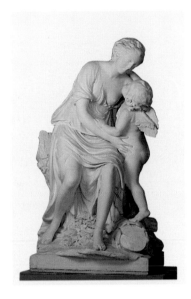

Page 8 verso, *c.*1895
After Jean-Baptiste Pigalle, *Love and Friendship*, marble
musée du Louvre, Paris

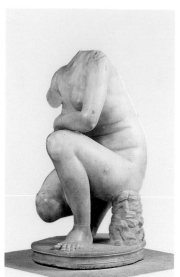

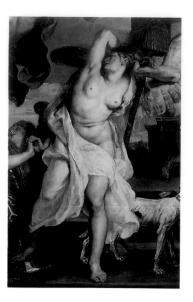

Page 3, 1894–1897
After *Crouching Venus* (after restoration), marble
musée du Louvre, Paris

Page 5, 1895–1898
After Bellona, *The Apotheosis of Henry IV* (detail), Rubens
musée du Louvre, Paris

Page 5 verso, 1892–1895
After Desjardins, *Bust of Pierre Mignard*, marble
musée du Louvre, Paris

Page 10 verso, 1894–1898
After *Satyr with Cymbals*, marble
musée du Louvre, Paris

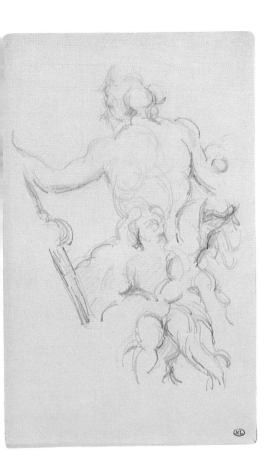

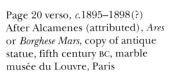

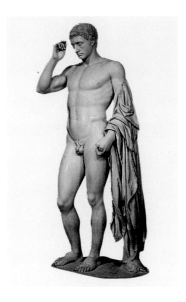

Page 20 verso, *c.*1895–1898(?)
After Alcamenes (attributed), *Ares*
or *Borghese Mars*, copy of antique
statue, fifth century BC, marble
musée du Louvre, Paris

Page 26 verso, *c.*1892–1895
After Cleomenes, *Roman Orator* or
Germanicus, 40–30 BC, marble
musée du Louvre, Paris

Page 27 verso, 1894–1898
After Cornelius van Cleve, *The Loire
and the Loiret*
Jardin des Tuileries, Paris (Cézanne
may have worked from a plaster cast
at the musée de Sculpture
comparée du Trocadéro, Paris)

Page 28 verso, 1890–1894
After *Bust of Lucius Verus*, marble
musée du Louvre, Paris

Page 32 verso, *c*.1895–1898
After *Foolish Virgin*, a statue from
Strasbourg Cathedral (Cézanne worked
from a plaster cast at the musée de
Sculpture comparée du Trocadéro, Paris)

Page 1, *c.*1890, After *Bust of Caracalla*, marble
musée du Louvre, Paris

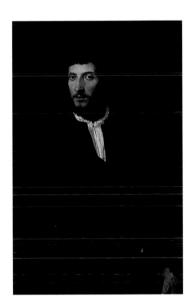

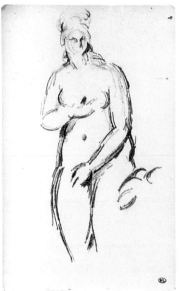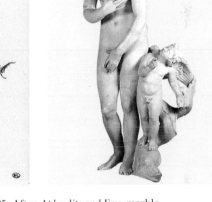

Page 2, 1892–1895, After Titian (attributed), *Portrait of a Man*, oil on canvas
musée du Louvre, Paris

Page 4, 1892–1895, After *Aphrodite and Eros*, marble
musée du Louvre, Paris

Page 6, 1888
Study of the Head of the Artist's Son

Page 7, 1887–1890
Study of the Nape of the Neck

Page 7 verso, *c.*1890
Study of a Flower

Page 30, After Puget, *Atlante* from l'Hôtel de Ville, Toulon
musée de Sculpture comparée du Trocadéro, Paris

Page 10, 1894–1897, After Charles-Antoine Coysevox,
Le Grand Condé, bronze, musée du Louvre, Paris

Page 3, 1892–1896, After *Crouching Venus* or *Venus of Vienna*, marble
musée du Louvre, Paris

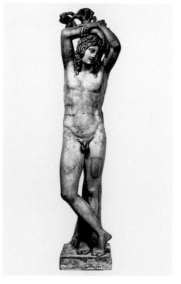

Page 27, 1890–18193, After *Genius of the Tomb*, marble
musée du Louvre, Paris

Page 30 verso, 1892–1895, After *Hermes*, marble
musée du Louvre, Paris

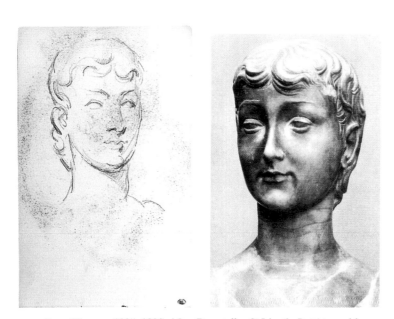

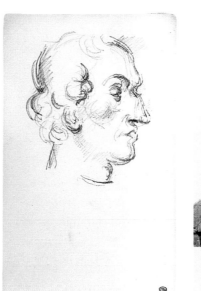

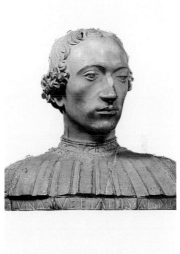

Page 12 verso, 1895–1898, After Donatello, *St John the Baptist*, marble
National Gallery (Bargello), Florence
(Cézanne worked from a plaster cast in the musée de
Sculpture comparée du Trocadéro, Paris)

Page 11 verso, *c.*1895, After Mino da Fiesole, *Rinaldo della Luna*, marble
National Gallery (Bargello), Florence
(Cézanne worked from a plaster cast in the musée de
Sculpture comparée du Trocadéro, Paris)

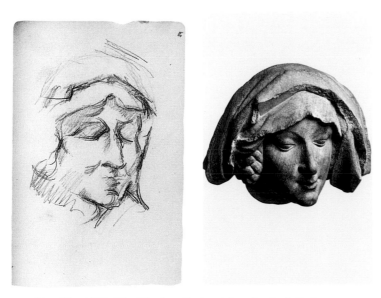

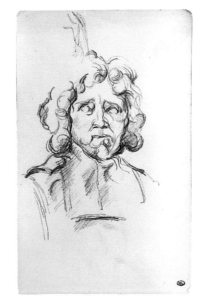

Page 29, *c.*1890, After Nicolaus Gerhaert (van Leyden), *Barbara von
Hottehmeim* or *Bärbele*, Muster alter Plastik, Frankfurt-am-Maine
(Cézanne worked from a plaster cast in the musée de Sculpture comparée
du Trocadéro, Paris)

Page 31 verso, 1892–1895
After Charles-Antoine Coysevox, *Michel Le Tellier*, bronze
Formerly in musée du Louvre, Paris (disappeared in 1939)

Biographical Outline

1839 19 January: Paul Cézanne is born at Aix-en-Provence. The son of Louis-Auguste Cézanne, dealer in and exporter of hats and a banker, aged forty, and of Anne Elizabeth Honorine Aubert, aged twenty-four. Paul is born out of wedlock but is acknowledged by his father.

1841 4 July: Marie Cézanne, the second child, is born.

1844 29 January: The parents marry in Aix-en-Provence, thus making the children legitimate.

1848 1 June: Banque Cézanne & Cabassol opens at 24 rue des Cordeliers, Aix-en-Provence; it moves to 13 rue Boulegon in 1856.

1850 Paul begins two years' attendance at École Saint-Joseph after having attended the local school.

1852 Paul starts to attend secondary school as a boarder at the Collège Bourbon (now the Lycée Mignet) with Émile Zola, Jean-Baptistin Baille and Louis Marguery. They are known as the 'Inseparables'.

1854 1 June: Rose Honorine Cézanne, a second sister, is born at Aix-en-Provence.

1857 (or 1858) Paul enrolls at the free School of Drawing in the Prieuré de Malte (the same place as the museum) in Aix-en-Provence.

1858 December: Paul is compelled by his father to read law at Aix University; he asks Zola, who is in Paris, to enquire about the entrance competition for the École des Beaux-Arts.

1859 25 August: Paul receives second prize for figure drawing at the School of Drawing.
15 September: Louis-Auguste Cézanne buys the Jas de Bouffan estate.

1860 February: Paul abandons his pretence of studying law, wishing to study painting in Paris.

1861 April: Against the advice of his teacher at the School of Drawing, Paul leaves Aix for Paris, where he stays until September, with Zola dictating his timetable and organizing his budget, and frequents the Atelier Suisse.
September: Probably after failing the entrance competition for the École des Beaux-Arts, Paul returns to Aix to work in his father's bank.

1862 Early November: Paul returns to Paris and enrolls again at the Atelier Suisse.

1863 15 May: The opening of the Salon des Refusés; Manet's *Déjeuner sur l'Herbe* causes a scandal. Cézanne exhibits at the Salon des Refusés but attracts no attention, although he meets Monet, Degas and Renoir. He applies for permission to make copies in the Louvre.

1866 April: Despite the intervention of Daubigny, Cézanne is refused by the Salon jury.
19 April: Cézanne sends a letter of protest to H. de Nieuwerkerke, the superintendent of Fine Arts, demanding the reinstatement of the Salon des Refusés.
27 April to 20 May: Writing under the pseudonym Claude, Zola publishes seven articles about the Salon in *L'Evénement*.
May to early August: Cézanne makes several visits to Bennecourt (Oise) together with Zola, Chaillan, Baille and Valabrègue. He occasionally visits the Café Guerbois, where Manet and his friends used to meet.

1867 April: Two of Cézanne's paintings, *The Wine Grog* and *Intoxication*, are turned down by the Salon jury.
Early June: Cézanne returns to Aix after spending part of the winter and spring in Paris.

1868 April: His work is rejected by the Salon jury.
May to December: He works in the south of France.

1869 Early in the year he meets Hortense Fiquet, a model or dress-maker from the Jura and eleven years his junior. She becomes his companion.

1870 31 May: Cézanne is a witness at the marriage of Zola and Alexandrine Meley at Paris. Following the outbreak of the Franco-Prussian War (19 July), he and Hortense Fiquet take refuge in L'Estaque for a year.
4 September: The Republic is proclaimed following the defeat at Sédan (2 September) and the capitulation of Napoleon III.
18 November: While at L'Estaque, Cézanne is elected chairman of the committee of the School of Drawing, but he does not attend meetings. The committee is dissolved on 19 April 1871.

1872 4 January: Paul, the son of Cézanne and Hortense Fiquet, is born at 45 rue de Jussieu, Paris. Cézanne acknowledges his son.
April: Cézanne is refused by the Salon. He signs a petition to the Minister of Culture and Fine Arts demanding that a room for the Refusés be opened in the exhibition at the Salon de l'Industrie.
August: Cézanne joins Pissarro, who has settled at Pontoise, outside Paris. He later moves to the nearby village of Auvers-sur-Oise.

1873 Cézanne spends the entire year with Hortense and their son at Auvers, walking to Pontoise every day to work beside Pissarro. At Auvers he, Pissarro and Guillaumin practise etching in Dr Gachet's studio.

1874 Early in the year he returns to Paris.
15 April to 15 May: Three of Cézanne's paintings are shown at the first Impressionist exhibition, including *The House of the Hanged Man at Auvers-sur-Oise*, which finds an immediate buyer.

1875 December: Père Tanguy sells three of Cézanne's paintings to Victor Chocquet, a customs official and collector of Delacroix and Renoir. (Until his death in 1894, Père Tanguy remained the only dealer in Paris to stock Cézanne's works.)

1876 April: Cézanne is in Aix and does not participate in the second Impressionist exhibition. He is refused by the Salon. From this time he works regularly at L'Estaque (now a suburb of Marseilles).

1877 Cézanne spends much of the year in Paris.
14–30 April: He exhibits sixteen works in the third Impressionist exhibition. He makes regular visits to the Café de la Nouvelle-Athènes and attends Nina de Villars's soirées, after having been introduced to her by Cabaner, the musician, or by Paul Alexis.

1878 March: He is in the south of France, at Aix, L'Estaque or Marseilles, where Hortense and Paul are living. Cézanne's father intercepts a letter from Chocquet, from which he learns about Hortense and his grandson, and threatens to stop his allowance. Cézanne considers looking for a job and asks Zola to help him.
28 May: Zola buys a house at Médan.
Summer: Cézanne stays at L'Estaque.

1879 Early April: Cézanne settles in Melun but regularly returns to Paris. He regularly visits Zola at Médan. During a hard winter he paints snowscapes.

1880 1 April: Cézanne leaves Melun for Paris.
August: Stays at Zola's house at Médan.

1881 May to October: Stays at Pontoise with Paul and Hortense. He sees Pissarro often and meets Gauguin. Between 1881 and 1885 Cézanne's father has the Jas de Bouffan re-roofed and takes the opportunity to build a studio there for his son.

1882 Second half of January: Renoir spends a few days at L'Estaque and again meets Cézanne. They work together in the open air.
May: A portrait by Cézanne is accepted by the Salon by subterfuge. (His name was entered on the register of the Salon as 'a pupil of Guillemet', a member of the jury.)
Summer: Cézanne is at Chocquet's house in Hattenville, Normandy.

November: In his will, Cézanne leaves his estate to his mother and his son.

1883 May: Cézanne stays at L'Estaque and explores the countryside around Marseilles and Aix with Monticelli. End of December: Monet and Renoir visit Cézanne at Aix. He works almost entirely in Provence until 1887.

1884 Cézanne works in Aix and at L'Estaque.

1885 He spends the first half of the year in Aix.
Spring: He has a brief and unhappy love affair and asks Zola to keep his correspondence for him.
15 June: He stays at Renoir's house at La Roche Guyon.
August: Cézanne is in Aix, from where each day he travels to Gardanne, a village about 12km away, returning to the Jas de Bouffan every evening.

1886 Cézanne is at Gardanne.
31 March: Following the publication of Zola's novel *L'Oeuvre*, Cézanne breaks with his friend.
28 April: Cézanne marries Hortense Fiquet in Aix-en-Provence, thereby making their son legitimate. His parents attend the wedding.
23 October: Cézanne's father dies.
17 December: Under the terms of their father's will, Cézanne and his sisters are left a substantial sum.

1888 January: Renoir makes a short visit to the Jas de Bouffan.
Summer(?): According to his son, Cézanne spent five months in Chantilly.

1889 June: Cézanne stays at Chocquet's house at Hattenville, Normandy.
July to October: With the help of Roger Marx, *The House of the Hanged Man at Auvers-sur-Oise* is exhibited at the Centenary of French Art at the Universal Exhibition. Cézanne is invited to exhibit with the Belgian group Les Vingts in Brussels.
Renoir visits Cézanne in Provence.

1890 January: Three of Cézanne's paintings are exhibited at the seventh annual exhibition of Les Vingts at the Palais des Beaux-Arts in Brussels.
Summer: Cézanne, Hortense and their son are at Emagny (Doubs). They visit Switzerland: Neuchatel, Berne, Fribourg, Vevey, Lausanne and Geneva. Cézanne begins to suffer from diabetes.

1891 At Aix. Hortense and Paul stay in an apartment while Cézanne, his mother and his sisters remain at the Jas de Bouffan.
May: 'Paul Cézanne' by Émile Bernard in the series *Les Hommes d'aujourd'hui* is published. On the cover is a portrait of Cézanne by Pissarro.

1892 Cézanne buys a house in a village near Marlotte.

1894 21 February: Gustave Caillebotte dies, leaving to the nation more than sixty-five works by Cézanne, Degas,

Manet, Monet, Pissarro, Renoir and Sisley. After much delay, only a few of the paintings are accepted, the rest being refused and returned to the heir. The inventory reveals that two out of four of Cézanne's works are among those accepted.
September: Cézanne works at Melun.
7–30 September: Cézanne stays at Hôtel Baudy in Giverny, where he visits Monet. Père Tanguy dies and six of Cézanne's works are bought by Ambroise Vollard, a then unknown dealer.

1895 Cézanne spends the first half of the year in Paris, the second half in Aix.
November: The first retrospective exhibition of his work is held at Vollard's gallery. Vollard persuades Cézanne to lend 150 works.
December: Cézanne participates in the first exhibition organized by the Société des Amis des Arts in Aix.

1896 Early in year: Cézanne meets Vollard for the first time.
March or April: The relationship begins between Cézanne and Joachim Gasquet, the son of his childhood friend, Henri Gasquet.
Early June: Cézanne has a month-long cure at Vichy.
July: At the request of his wife and son, Cézanne holidays at Talloires, on the shore of Lake Annecy. Two of his works from the Caillebotte Bequest are accepted by the Luxembourg Gallery.

1897 Cézanne works at Mennecy (Essonne), then at Aix.
June(?) to September: He rents a country house in Le Tholonet until the autumn, working in the open air on landscapes and the Bibémus quarry.
25 October: Cézanne's mother dies at Aix. The director of the Berlin National Gallery buys two of Cézanne's paintings from Durand-Ruel, only to have them banned by the Kaiser.

1898 Cézanne spends the first half of the year at Aix and the second half in Paris.
9 May to 10 June: Sixty of his paintings are exhibited at Vollard's gallery.

1899 After a few months in Paris, Cézanne returns to Aix. His canvases are commanding high prices in the sale of the Chocquet collection.
18 September: Cézanne sells the Jas de Bouffan.
Autumn: He returns to Aix to sort out moving and clearing his studio and rents an apartment at 23 rue Boulgeon, where he has a studio built in the attic.
21 October to 26 November: He exhibits two still lifes and a landscape at the Salon des Indépendants.
End of November to December: Forty of his paintings are exhibited at Vollard's gallery.
End of year: Vollard buys his entire studio stock.

1900 November to early January 1901: Thirteen of Cézanne's painting (twelve sent by Durand-Ruel) are exhibited for the first time in a group exhibition at the Bruno and Paul Cassirer Gallery in Berlin.

1901 20 April to 21 May: Two of Cézanne's paintings are exhibited at the seventeenth Salon des Indépendants.
16 November: He buys a small country house and land in the Lauves district, north of Aix, and supervises the building of a studio there.

1902 29 March to 5 May: Three of his paintings are exhibited at the Salon des Indépendants.
26 September: He makes a handwritten will, designating his son as his only heir.
29 September: Zola dies in Paris; Cézanne is deeply affected by his death.

1903 6–13 March: The sale by auction of part of Zola's estate is held at the Hôtel Drouot; this includes nine of Cézanne's paintings, of which Auguste Pellerin buys five.
31 October to 6 December: Cézanne exhibits for the first time at the Salon d'Automne (although his name does not appear in the catalogue).

1904 4 February: Émile Bernard, returning from Egypt via Marseilles, spends a month at Aix, working in a ground-floor room of Cézanne's studio. They also work together in the open air.
July: 'Paul Cézanne', an article by Émile Bernard, is published in L'Occident.
15 October to 15 November: An entire room at the second exhibition of the Salon d'Automne is devoted to Cézanne's work.

1905 January to February: Ten of his paintings are included in a group exhibition organized by Durand-Ruel at the Grafton Galleries in London.
End of March: Émile Bernard visits Cézanne for the last time.
Summer: Cézanne works at Fontainebleau.
8 October to 25 November: Ten paintings are exhibited at the Salon d'Automne in Paris.

1906 6 October to 15 November: Ten of his paintings are included in the Salon d'Automne.
15 October: Working outdoors, Cézanne collapses in a sudden thunderstorm and is carried home in a laundry cart.
16 October: After going to his studio to work on Vallier's portrait, he returns home, unwell.
22 October: Madame Brémond, the house-keeper, sends a telegram to his son to say his father is dying. His wife and son arrive too late.
23 October: Cézanne dies at seven o'clock in the morning at his home, 23 rue Boulegon, aged sixty-seven.
24 October: Cézanne's funeral takes place at the Cathedral of Saint-Sauveur, Aix-en-Provence.

1907 1–16 October: 'Souvenirs sur Paul Cézanne' by Émile Bernard is published in the Mercure de France (republished 1925).

Further Reading

Adriani, G., *Cézanne Watercolours*, New York, 1983

Badt, K., *The Art of Cézanne* (translated by Sheila Ann Oglivie),
 Berkeley, Los Angeles and London, 1965

Cachin, Françoise and Rishel, Joseph J., *Cézanne*, exhibition
 catalogue,Tate Gallery, London, 1996

Chappuis, A., *The Drawings of Paul Cézanne* (2 volumes), Greenwich,
 Connecticut, and London, 1973

Doran, P.M. (ed.), *Conversations avec Cézanne*, Paris, 1978

Gowing, L., *Cézanne: The Early Years, 1859–1872*, exhibition catalogue,
 Royal Academy of Arts, London, 1988

Gowing, L., *Watercolour and Pencil Drawings by Cézanne*, London, 1973

Howard, M. *Cézanne*, London, 1990

Kendall, R., *Cézanne by Himself*, London, 1988

Merleau-Ponty, M., 'Sense and Non Sense', Paris, 1948, reprinted in
 J. Weschler (ed.), *Cézanne in Perspective*, Englewood Cliffs,
 New Jersey, 1975

Rewald, J., *Paul Cézanne, A Biography*, London and New York, 1939
 (revised 1978)

Rewald, J. (ed.), *Paul Cézanne's Letters*, Oxford, 1976 (4th edition)

Rewald, J., *Paul Cézanne: The Watercolours, A Catalogue Raisonné*,
 London and New York, 1983

Rewald, J., *Cézanne, A Biography*, London and New York, 1986

Rubin, W. (ed.), *Cézanne: The Late Work*, exhibition catalogue,
 Museum of Modern Art, New York, 1977

Schapiro, M., *Cézanne*, New York, 1965

Shiff, R., *Cézanne and the End of Impressionism*, Chicago and
 London, 1984

Venturi, L., *Cézanne, son art, son oeuvre* (2 volumes), Paris, 1936

Verdi, Richard, *Cézanne and Poussin: The Classical Landscape*, exhibition
 catalogue, National Gallery of Scotland, Edinburgh, 1990

Index of Names and Works

Page numbers in **bold** are to illustrations; page numbers
in normal type are to text references

Principal Museums and Collections

The following are some of the major museums and art galleries possessing some of Cézanne's works. Page references in **bold** type are to works illustrated in this text.

Photographic Credits

Acquavella/Scott Brown Photography, New York 12; Agence Novosti, Paris 86 (top), 112 (top) and 114; Agence photographique de la Réunion des musées nationaux 31 (bottom), 76, 132 (top, third from left); 133 (top, third from left, bottom, third from left); 135 (except centre, second from left and far right); 136 (all drawings; bottom, second from left); 137 (all drawings); Christine Arasse/Éditions Somogy 25 (bottom); Arquivio Nacional de Fotografia/Instituto Portugues de Museus 56; Art Institute, Chicago, 61 and 65; Barnes Foundation, Merion, Pennsylvania 106 and 126; Beyeler Collection, Basle 129; Foundation Collection of E.G. Bührle, Zurich 85 and 88; Burrell Collection, Glasgow Art Gallery 97 (left); Cincinnati Art Museum, Cincinnati 39; A.C. Cooper 41; County Museum of Art, Los Angeles 68 and 70 (bottom); Courtauld Institute Galleries, London 99 (right), 101 and 110; Philippe Fuzeau/Éditions Somogy jacket, 4, 5, 17, 20, 23 (bottom), 27 (right), 32, 38, 43, 48, 49 (right), 53, 55 (bottom), 57, 61, 64 (bottom), 66, 67, 70 (top), 71, 73, 78, 82, 93 (bottom) and 128 (top); Giraudon, Paris 113 (bottom); Hans Hinz/Arthotek, Peissenberg 35 (left) and 124; Luiz Hossaka, São Paulo 42, 51 and 61; Frédéric Joncour/Éditions Somogy 16, 18, 22 (left and right), 23 (top), 26, 27 (right), 31 (bottom), 36, 40, 49 (right), 50, 55 (top), 69, 74 (top), 75, 83, 86 (bottom), 94, 95, 118, 130, 131, 132 (except top, third from left); 133 (except top, third from left and bottom, third from left); 134; 135 (centre, second from left; centre far right); 136 (top right; centre second from left; centre, far right; bottom extreme right); 137 (bottom, far right); Provost and Fellows of King's College, Cambridge 44 and 45; Kröller-Müller Museum, Otterlo 93 (top right); Kunstmuseum, Soleure 107; Liebieghaus, Museum alter Plastik, Frankfurt-am-Main 137 (bottom, second from left); Metropolitan Museum of Art, New York 81; Museum of Art, Philadelphia 113 (top), 115, 116 and 122; Museum of Fine Arts, Boston 79; Museum of Modern Art, New York 123; Rights reserved 10, 11, 13, 21, 22 (centre), 25 (top), 27 (left), 29, 31 (top left) 35 (right), 36, 40, 49 (right), 50, 52, 63, 64 (top), 72 (bottom), 91 (bottom), 99 (right), 104, 105, 119 and 128 (bottom); Trustees of the National Gallery, London 127; Board of Trustees, National Gallery of Art, Washington D.C. 46, 59, 87, 109 and 121; National Galleries of Scotland, Edinburgh 112 (bottom); National Gallery, Prague 91 (top); Photothèque des musées de la Ville de Paris/Pierrain/Spadem 37 and 103; Scala, Florence 47 and 137 (top, second from left; top, far right); Galerie Schmit, Paris 28, 72 (top) and 90; Bernard Terlay, Aix-en-Provence 31 (top right) and 93 (top left); Mr and Mrs E.V. Thaw 30, 74 (bottom) and 98; Van Gogh Museum, Amsterdam 84; Walker Art Gallery, Liverpool 19.